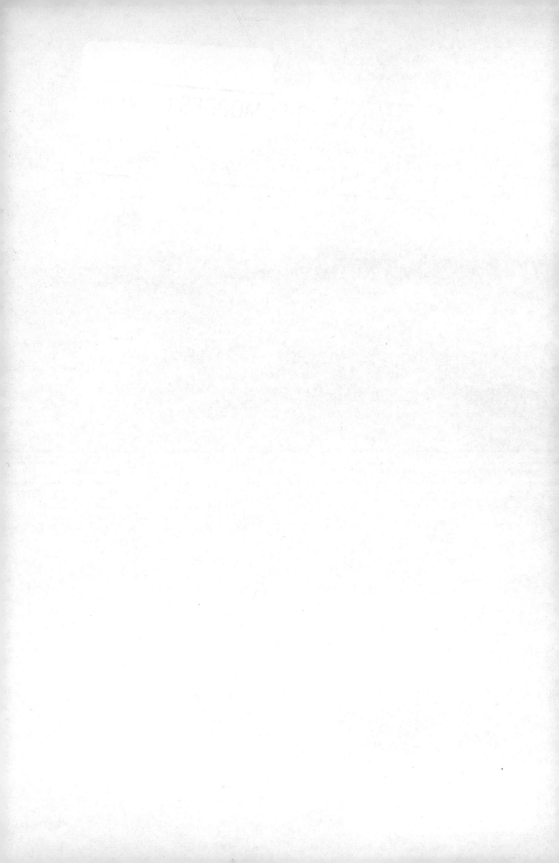

RELATIVE VALUES

RELATIVE VALUES

or

What's Art Worth?

Louisa Buck and Philip Dodd

BBC Books

© Louisa Buck and Philip Dodd 1991

ISBN 0 563 20749 3 paperback
ISBN 0 563 36118 2 hardback

Published by BBC Books
a division of BBC Enterprises Ltd
Woodlands, 80 Wood Lane, London W12 0TT

Set in 11/14 pt Bodoni by
Ace Filmsetting Ltd, Frome, Somerset
Printed and bound in Great Britain by
Butler & Tanner Ltd, Frome, Somerset

Contents

Picture credits

Page 8 Courtesy Sidney Janis Gallery, New York, Collection Carroll Janis, Conrad Janis, photo: Otto E. Nelson, © ADAGP, Paris, and DACS, London, 1990 **11** Kobal Collection **12** (*top*) Bridgeman Art Library; (*bottom*) Mansell Collection **15** Guerrilla Girls New York **20** Hulton-Deutsch Collection **23** Louvre, Paris, Photographie Bulloz **24** (*top*) Scala; (*bottom*) London Weekend Television **28** © Timothy Greenfield-Sanders, Courtesy Comme des Garçons **29** © Christie's, photo A. C. Cooper **30** Private Collection, Courtesy Marlborough Fine Art (London) Ltd **31** Bibliothèque Nationale, Paris **34** Giraudon **37** (*top*) Musées Royaux Des Beaux-Arts, Brussels, © A.C.L. Brussel; (*bottom*) © Anton Perich **40** Bibliothèque Nationale, Paris, Service Photographique **41** (*top*) Louvre, Paris, photo Giraudon; (*bottom*) Reproduced by gracious permission of Her Majesty Queen Elizabeth II, photo Rodney Todd White **44** City Museum and Art Gallery, Bristol **46** British Film Institute **49** © Hans Namuth 1990 **50** Collection: Robert Scull, New York, Bridgeman Art Library, © DACS 1990 **51** Metro Pictures, New York **54** Courtesy: Mary Boone Gallery, New York, photo Zindman Fremont **55** Associated Press, photo Tim Clary **56** Hulton-Deutsch Collection **59** The Saison Group **62** Serpentine Gallery, London, photo Rebecca King Lassman **64** Ephemera Society **69** Courtesy of Colnaghi, London **70** By permission of the Houghton Library, Harvard University **71** Hulton-Deutsch Collection **72** Nicola Jacobs Gallery, London, *Harpers & Queen* Magazine **75** Lisson Gallery, London, photo Susan Ormerod **76** Barbara Gladstone Gallery, New York, and the Artangel Trust **79** Palazzo Vecchio, Florence, photo Scala **81** (*top*) Courtesy the *New Yorker* Magazine; (*bottom*) © BBC, photo Beth Millward **83** Metropolitan Museum of Art, New York, photograph by the Egyptian Expedition **85** The Prado, Madrid, photo Lauros-Giraudon **86** Private Collection, courtesy James Kirkman **90** John Weber Gallery, New York **92** (*top*) © Dan Cornish/Esto Photographics; (*bottom*) © Jeff Koons, courtesy Sonnabend Gallery, New York **97** (*top*) John Weber Gallery, New York; (*bottom*) /Courtesy Citibank Art Advisory Service, Citi Corp **99** Kunsthistorisches Museum, Vienna **101** Copyright 1990 The Estate and Foundation of Andy Warhol/ARS N.Y. **102** Skystone Foundation, Arizona **107** Mansell Collection **108** Pace Gallery, New York **115** Collection of Whitney Museum of American Art. 50th Anniversary Gift of The Gilman Foundation, Inc., The Lauder Foundation, A. Alfred Taubman, an anonymous donor, and purchase 80.32, © DACS 1990 **118** French Government Tourist Office **119** National Portrait Gallery, London **122** (*left*) © Christie's; (*right*) National Gallery of Art, Washington; Gift of the W. Averell Harriman Foundation in memory of Marie N. Harriman **123** Museum of Mankind, British Museum, London **125** Gimpel Fils Gallery, London, collection Frances Balfour **127** photo Pablo Butcher **129** Patrick Vilaire **131** © Courtesy, Anthony d'Offay Gallery, London **134** Metropolitan Museum of Art, New York **136** © Courtesy, Anthony d'Offay Gallery, London **140** © BBC, photo Beth Millward **143** The J. Paul Getty Museum, California, © photo Julius Shulman **144** (*left*) Culver Pictures; (*right*) Mansell Collection **146** Roger-Viollet, Paris **149** Arcaid, photo Richard Bryant **151** Richard Rogers Partnership **152** Metropolitan Museum of Art, New York **153** © Louis Helliman **155** Massachusetts Museum of Contemporary Art; photo John M. Kuykendall **159** © Daniel J. Terra Collection, Terra Museum of American Art, Chicago

Acknowledgements

Our first debt is to the team of people who together with one of the authors, Philip Dodd, made the television series which this book complements and who helped to shape the arguments of the book: Keith Alexander, Charles Chabot, Robert McNab, Jane Mayes, Hannah Rothschild, Jake Auerbach and Nick Rossiter.

We are especially indebted to Sheila Ableman at BBC Books who first commissioned the project and has shown unfailing enthusiasm; to Martha Caute for her forbearance, good humour and splendid editing; to David Cottingham, the picture researcher, for his invaluable enthusiasm and imagination; and to the designer Tim Higgins for his care and creativity.

As this is a work addressed to a popular audience footnotes seemed inappropriate. But this should not disguise the fact that we are greatly indebted to the work of scholars: we acknowledge our sources at the back of the book.

We are also grateful to Meg Duff and Krzysztof Cieszkowski at the Tate Gallery Library; Colin Gleadell; George Melly; Frances Abraham; Anna Ottewill; Jane Gordon-Cumming; Harriet Laver; Peter Townsend and Deanna Petherbridge.

Our greatest thanks are due to Kathryn Dodd and Tom Dewe Mathews.

Louisa Buck and Philip Dodd

Marcel Duchamp, *Fountain* (1917). Readymade porcelain urinal, turned on its back. The original, now destroyed, was rejected for exhibition by New York's Society of Independent Artists in 1917, but this copy, known as 'the second version', has since been exhibited worldwide, most recently at the travelling exhibition 'High and Low – Modern Art and Popular Culture' which opened at the Museum of Modern Art, New York, in October 1990. Why should we call this a work of art?

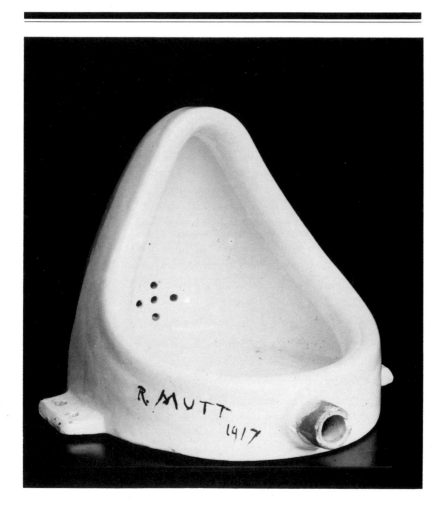

Introduction

We build elaborate temples to house art and we worship artists with a fervour that was once reserved for saints. Extravagant sums of money are paid to possess artworks and nations vie with one another to be the centre of the art world.

And yet, why do we value art so highly? What would visitors from another planet make of the queues of idolatrous people who pass reverently through museums or attend an auction where a vast amount of money is paid, not for a vase of real sunflowers but for its representation on canvas in a mixture of oil and pigment? How would extraterrestrial observers comprehend the activity of people who spend days on end trying to represent the landscape outside their studios or working on a particular configuration of colour and shape which does not appear to represent anything in the external world?

How can we justify the commitment and passion lavished on objects which look insubstantial and seem to be of no practical use? Can even those with a love of art explain to the uninitiated why it is that they value art as they do or the nature of that which they hold in such high esteem?

After all, it is not easy to recognize what can be singled out as a 'Work of Art'. And this is not simply the consequence of twentieth-century developments which have extended the range of materials that art can now be made from, although such revolutions in art making are clearly important. When 120 firebricks can be laid out on the floor of a national gallery and given the gnomic title *Equivalent VIII* – as happened at the Tate Gallery in 1972 in a piece by the American artist Carl Andre – it hits home that the term artwork now

*❝Painting is a cultural activity – it's not
like spitting, one can't kid oneself.❞*

Frank Auerbach, artist

covers a very wide range of things indeed. Yet even conventional
and widely-acclaimed works such as the paintings of Titian or the
sculptures of Bernini do not announce themselves as 'Works of Art'.
They are paintings and sculpture: marks on canvas, carved stone or
cast bronze. Paintings and sculpture can be touched and described
– but what constitutes a Work of Art?

As material objects it can be said that artworks don't exist at all,
even if paintings and sculptures do. In the same sense there are
some novels that we call Literature in order to distinguish them
from other novels that we call fiction or even trash. Yet these valued
novels do not proclaim themselves as 'Literature'. George Eliot's
Middlemarch doesn't announce that it is Literature on the title page.
The term is our way of recognizing and evaluating certain works at
the expense of others. And so it is with painting and sculpture, as
well as the many works made from materials that fall into neither of
these two categories.

What do we call the paintings that are hung up for sale on the
railings of Hyde Park on summer weekends, or the ones that are
bought at holiday resorts by visitors who want to remember pleasur-
able times? In what sense are these acknowledged as Art? It is cer-
tainly unusual to hear them described in this way, yet in terms of the
materials and conventions used in their construction they may be
indistinguishable from paintings that are recognized as great art.
Even many of the objects that we now define as major works of art –
from Giotto's *Ognissanti Madonna* to the Benin bronzes of Nigeria –
were not considered primarily as Art as we understand the term
when they were originally made. They were seen rather in func-
tional terms, as expressions of religious devotion.

Kirk Douglas as Vincent Van Gogh in
Vincente Minnelli's *Lust for Life* (1956).
Have Hollywood bio-pics of the mad suffering
artist sustained the idea that the artist
is someone special, unlike the rest of us?

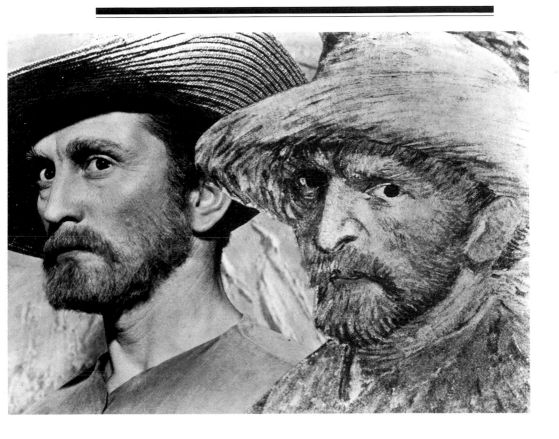

Above: Alexandre Cabanel, *Birth of Venus* (1863)
Below: Edouard Manet, *Olympia* (1863, exhibited in the Salon
of 1865). Does it matter that the nineteenth-century valuation
of these pictures was different from our own?

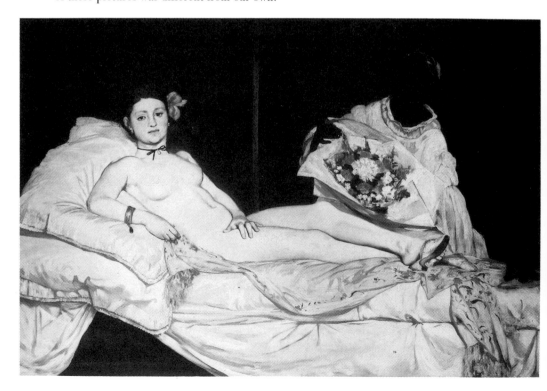

■■ INTRODUCTION ■■

*❝For the "works of art themselves" is of course a
category, and not some neutral objective description.
It is a socio-cultural category of the
highest importance. ❞*
Raymond Williams

When a painting is valued as a Work of Art – or even when it is
created with that intention in mind – there is no guarantee that it will
retain that status. When Alexandre Cabanel's *Birth of Venus* was
first exhibited in 1863, it was greeted with great acclaim, but two
years later Manet's *Olympia* was met with anger, disbelief and
abuse. Yet until Cabanel's painting was displayed in the Musée
d'Orsay in 1988, who besides scholars even knew of its existence,
let alone valued it? Museum vaults of the great national collections
are full of works once hailed as masterpieces that now have fallen
from grace.

Just as neglect has been the fate of some works which were at first
lauded, there is also the case of artists, sometimes initially well-con-
sidered, other times not, who are wiped off the historical record or
neglected by subsequent critical and institutional judgement, only
to be brought back to prominence by particular political and social
groups. Women artists, both as individuals and as a group, are a
clear example of this. Feminism's energetic recovery of women's
hitherto hidden history of creativity has led to the revaluation of
such women artists as Artemisia Gentileschi, who was a contem-
porary of Rembrandt, and to the identification of large numbers of
women artists; as well as to attempts to understand how sexual dif-
ference has determined the history of art. Feminist criticism has
revealed how the work identified as Art by art historians is always a
selection from what is available in the past, and that this selection is
shaped by current concerns and interests. It has confirmed that
what counts as Art is always a social matter. Why, for instance, has
art history in the Western world tended to value oil painting over,
say, weaving? Is the latter dismissed as a lesser art on the grounds

Opposite: Posters flyleafed around New York by
the Guerrilla Girls – a group of women activists
working within the US art world.

that it is now seen only as women's work? Under what circum-
stances was this judgement made and by whom?

What becomes clear is that what counts as Art is a complex
matter. The term 'Art' is very unstable – shifting through history and
across cultures, settling on certain groups of objects as well as on
individual items in particular places at particular times. But it is not
sufficient that we simply see the past as being something other than
the present. We need to understand why and how it was different,
and why and how we have arrived at the present. For instance, we
know that societies earlier than our own valued originality less than
we do. When did the emphasis on artistic authenticity arise, in what
circumstances and why? Whose interests did it serve? How do these
attitudes from the past settle in the present? To set ourselves this
task is to try to unravel and unsettle the present and to show how it
came into being – and how it might be changed again. It is to show
that the present orthodoxy is a selection from the past and may be
remade. It is to show that the commonplaces of the present do not
necessarily have any value beyond the current status they enjoy.
This is not to argue that 'anything goes', or that we cannot say that
this artwork is better than that one. But it is to claim that what
is valued as Art is more than a matter of individual taste and
judgement.

To say this inevitably calls into question the assumption that Art
means one thing across space and time, and that the value of art is
stable and can transcend history. In one clear sense the argument of
this introduction, as well as of the book as a whole, is that the value
of art doesn't transcend history but is rather constituted by it; that
the particular value given to art is itself subject to, although not

[14]

THE ADVANTAGES OF BEING A WOMAN ARTIST:

Working without the pressure of success.

Not having to be in shows with men.

Having an escape from the art world in your 4 free-lance jobs.

Knowing your career might pick up after you're eighty.

Being reassured that whatever kind of art you make
 it will be labeled feminine.

Not being stuck in a tenured teaching position.

Seeing your ideas live on in the work of others.

Having the opportunity to choose between career and motherhood.

Not having to choke on those big cigars or paint in Italian suits.

Having more time to work after your mate dumps you
 for someone younger.

Being included in revised versions of art history.

Not having to undergo the embarrassment of being called a genius.

Getting your picture in the art magazines wearing a gorilla suit.

Please send $ and comments to:
Box 1056 Cooper Sta. NY, NY 10276

Guerrilla Girls CONSCIENCE OF THE ART WORLD

reducible to, the values of the social groups and institutions which address it.

This soon becomes evident if we trace the meaning of the word 'art' through its history. The word itself came from the Latin *artem* meaning skill, and certainly up until the early Renaissance a painter or sculptor was recognized by what he (and it generally tended to be a he) produced to earn a living. It was not until the late eighteenth century that a particular class of painter became fully absorbed into the category of 'artist' as distinct from artisan. From this time the artist became a person who was seen to incarnate values inimical to the new industrial order; he offered uniqueness and originality in an age of increasing mass production. But that uniqueness was not available to all. Women were excluded from the category, as were people from non-European cultures whose work often needed anthropology, a nineteenth-century invention, to explain it.

The artist was seen then, and we are still living with that assumption, as a particular kind of person – creative, imaginative, special – rather than the possessor of certain skills. It was during the same period that a term related to art also came to have its modern meaning. For if the artist created a particular kind of work, then its properties, intentions and effects needed a name: the aesthetic. Thus, from the late eighteenth century, art, which previously had served numerous functions, was now said to serve a particular one, centred on 'beauty', 'harmony', 'proportion' and 'form'. It is this historical flux that allows us to say that the value of art is relative, inseparable from the institutions and social groups which make and consume it, and that its meaning and value are shaped and reshaped by the larger history of which it is a constitutive part.

❛It's not erotic because it's good art.
The aesthetic emotions do not resemble the
sexy emotions. ❜

Tim Hilton, *The Guardian*, 6 June 1990

Each of the following chapters explores one of the major ways in which objects have been and continue to be translated by critics, institutions, traditions and consumers into that magical category of Art. This book does not attempt to provide a fully historical account of these factors, but instead it tries to understand how they operate at present, and in order to do so moves back and forth from the contemporary art world to key moments in the past when art and the understanding of art were changing in radical ways.

The first chapter explores our understanding of the Artist-as-Genius, how this notion arose and how the changing idea of the artist shapes our understanding of art. This magisterial figure is almost always a man – just think of a phrase that, until recently, we used unthinkingly: Old Master. Whatever the genius touches he turns into art, while his life gives a particular value to the art he makes. When Marcel Duchamp submitted a urinal to the 1917 exhibition of the Society of Independent Artists in New York, he was demonstrating that art was what an artist did rather than a recognizable artefact: if an artist created it, it must be art. Although the biographical is now the commonplace way of talking about art – this is a Rembrandt, that is an Andy Warhol – there is no necessary reason why we should bring together, in terms of a biographical narrative, works by the same painter. Why should we assume that an early and a late Picasso will illuminate each other simply because they were painted by the same man? It may be just as instructive to refer the two works to their relevant historical context – to the institutions, to the work of fellow artists, and the dominant artistic conventions within which the works were made.

The second chapter examines the art market – how it turns

6The making of art is extremely élite, the selling of art is élite. It's a highly specialised thing. It's the ultimate consumer product in our society.9

Leon Golub, artist

objects into art and gives a particular value to the things that it processes. It is not simply that the art market sells art, but that it can transform what it sells into artworks. By processing, say, an object from a non-Western society in terms which allow it to be recognized as art, the market has the capacity to bestow on things the valuation of art. The common claim that art is opposed to commerce, and that money contaminates art, may be historically false. The recognition of art as a commodity may in fact be one of the central ways in which its specific character has been isolated and valued.

The third chapter analyses collectors. Why is it that the rich and powerful – or those who wish to become so – gravitate towards art? In what terms do they value art? What do they think they are getting when they buy it? A kind of immortality? Something that will redeem their money-making activities? And now that corporations as well as individuals buy art, will art be valued anew? Or have corporations been commissioning and collecting art from the time of the Vatican Collection and even before? Is it simply nostalgia that leads us to believe that collectors from periods other than our own are preferable to contemporary ones?

The fourth chapter focuses on how the nation uses and takes responsibility for art. We are accustomed to hear, for example, about the intrinsic 'Englishness' of Constable's art or the 'Spanishness' of Velázquez's paintings. But how do painters come to represent a particular nation both to themselves and to others, and in what terms are they valued? In what ways do nations use art in the diplomatic battles where to be the centre of the art world is a matter of national pride? This is not new – art has been the continuation of diplomacy by other means for a very long time.

[18]

The last chapter looks around the museum, the place where most of us now experience art. It tries to explain what happens to objects when they are staged in museums and what valuation such places give to their objects. A public art gallery is, after all, a repository for an odd assortment of objects which range from offerings made for churches to commissioned portraits for the houses of the powerful, and includes works whose destination was always the public museum or art gallery. Yet the museum weaves its remarkably diverse contents together into one single story, albeit one with many different chapters.

Of course in history the institutions and categories which we have isolated in individual chapters do not divide into neat entities, instead they overlap and are interlocking processes within the wider social world. They have only been separated here to enable a clearer examination of why we value art as we do.

The determination of this argument is to restore to art its social character and to free it from the isolation to which it has often been condemned. One response to this approach may be to say that the artist, the market, the museum and the rest may surround but do not impinge on the art itself. But is this the case? After the notion of the romantic genius with his originality and artistic signature became established, then this figure with his distinguishing characteristics could himself become a subject-matter for art. Andy Warhol's self-portraits, with their overtly mechanical silk-screening process and thus their ostensible lack of expressivity, at once threw into ironic prominence – and mocked – the identification of the Artist-Genius with originality and expressiveness. And many of today's artists, from Allan McCollum to Jeff Koons and Anselm Kiefer, comment

Toms, after Van Heemskerck,
Satire on a Picture Auction (*c.*1730)

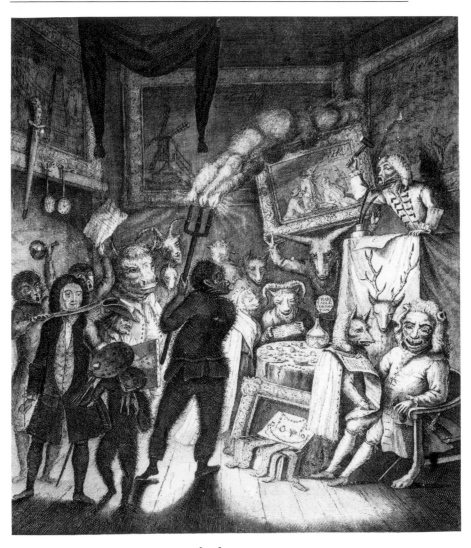

An objet d'art *creates a public that has artistic
taste and is able to enjoy beauty – and the same can
be said of any other product. Production accordingly
produces not only an object for the subject, but also
a subject for the object.*

Karl Marx

in different ways on the abiding mythology that surrounds artistic
genius.

Or consider the rise of the market and the abandonment of the
artist to its often less-than-tender mercies. The costs of that aban-
donment have often been logged, although never more poignantly
than in the phrase of William Blake, the poet and visionary artist,
'the desolate market in which none come to buy'. But the expansion
of the art market also offered to the artist possibilities as well as con-
straints. Freed from service to the church or its secular successor,
the demanding patron, the artist did and does at least have more
control over iconography and subject-matter. But the use to which
this artistic freedom is put is another thing altogether.

The shift in the destination of an artwork – from church to court
and from private house to museum – also caused a change in the
character of the art itself. Once the context of a work could be
assumed to be the museum then a certain kind of art was produced
which made the museum part of its meaning. When Marcel
Duchamp hung 1200 bags of coal on the ceiling of the International
Exhibition of Surrealism in Paris in 1938, he was defiantly insisting
that the context of the work – and who had considered the ceiling of
a gallery before? – was part of the work's meaning. On a much more
simple level the museum alters the meaning of already existing
objects that were made for other places. Compare, for instance, the
display and response to an altarpiece in a church with its presenta-
tion and the viewer's reaction in a museum.

Even in the case of national art, artists have been aware of its
importance in both critical and marketing terms, and this has
encouraged some of them to build that awareness into their art.

Opposite: Jacques Louis David,
The Coronation of Napoleon (detail, 1805–6)

Steven Campbell, a Glasgow painter who was marketed throughout the 1980s as one of a new 'Glasgow School', has played with clearly recognizable Scottish iconography in his work as a way of responding to the packaging of art in national terms. There are plenty of precedents to show that at certain moments in history artists have willingly taken on national responsibilities: from Jacques Louis David, painter to the new French Republic after the revolution of 1789, to the Haitian painters who painted murals on to any available wall to celebrate a new Haiti after the overthrow of Baby Doc Duvalier in 1986.

So it is hard to defend the claim that art is just there, an adamantine rock surrounded by enemy aliens that threaten its autonomy. Art is a profoundly social activity, something fought over by differing social groups and constantly remade by historical forces. To see art in these terms is maybe to deny its autonomy, but it is also to rescue it from isolation and to return it to the lives of all of us – which is where it belongs.

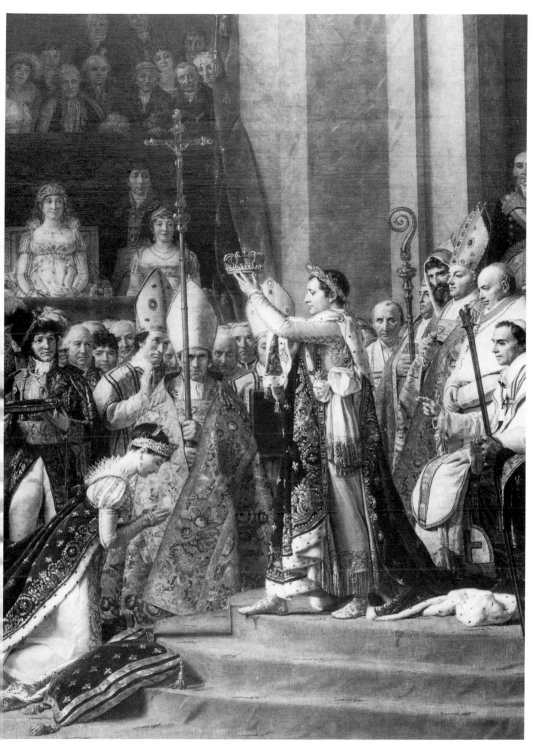

Below: Detail of Michelangelo's *Creation of Man*
(1508–10) in the Sistine Chapel, Vatican City, Rome
Bottom: The graphic designer conjures up memories of
Michelangelo's genius to introduce London Weekend
Television's arts programme *The South Bank Show*.

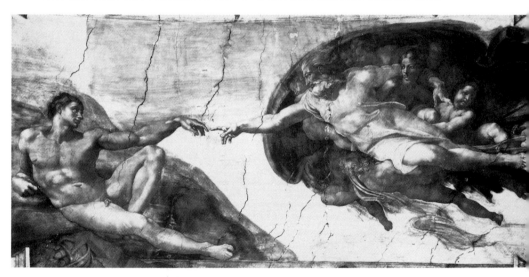

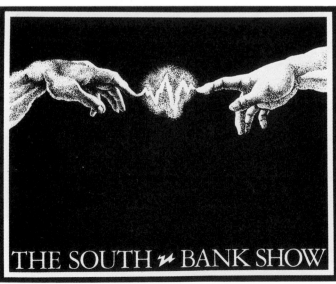

THE SOUTH BANK SHOW

The Agony and the Ecstasy

I s it possible to imagine art without the artist? Not if current ways of thinking about art are any guide. What would art history do without the artist-monograph or the *catalogue raisonné?* The art market, too, feeds off and nourishes the sacredness of major artists. If it can be established that a painting is, or is not, say, a Rembrandt, then there will be dramatic consequences. Although the painting will not in itself have changed in any way, a change in attribution will affect the painting's price and likewise the judgement of its aesthetic value. In the market, authorship is sometimes all.

No less in art tourism, the artist is the crucial icon. There are shrines to individual artists – sometimes museums (the Picasso museums in Barcelona and Paris are examples) or perhaps a house associated with an artist. The inn at Auvers where Van Gogh killed himself has been renovated by a Belgian art lover, under the auspices of the Van Gogh Institute, for visitors to come and pay homage.

The line dividing such enterprises from more explicit commercial exploitation of the artist is narrow – but there is no doubt that biography fuels the popular concern with art. The artist has gained currency via a plethora of popular films and books in which biographical drama usually eclipses artistic output – and is always its source. Hollywood films such as Carol Reed's *The Agony and the Ecstasy* (1965) and Vincente Minnelli's *Lust for Life* (1956) featured, respectively, the work of Michelangelo and Van Gogh, but in both cases relegated it to the background of the main events of the artists' lives. Such films draw upon and corrupt the idea of the Romantic Artist, the isolated but exceptionally gifted painter neglected by his contemporaries.

It is not merely Hollywood and the institutions of art that celebrate the artistic genius. Homage can be paid by other artists which, inevitably, and whatever the intention, fuels interest in the notion of the Artist-Genius. The fashion amongst nineteenth-century painters to represent scenes from the lives of selected Old Masters could not but intensify adoration of the artist. And one cannot ignore how Francis Bacon's 1957 exhibition at the Hanover Gallery in London, which showed paintings of Van Gogh as a neurotic figure, helped to stabilize the view of Van Gogh as a tortured genius and a model for serious artists.

Before we go any further, it should be said that 'the Artist' is almost always male. On the back cover of the paperback edition of Irving Stone's *Lust for Life*, the biography of Van Gogh on which Carol Reed's film was based, are the words,

> He didn't just kiss – he crushed!
> He didn't propose – he demanded!
> He was not just a man – he was a lover!
> With a consuming LUST FOR LIFE.

Here, more explicitly than usual, the masculinity of 'the Artist' is assumed and celebrated.

With so much attention paid to the artist, and with the marketability of his status, it is small wonder that certain artists have taken the actual image of 'the Artist' and sold it like a commodity. The best example remains Andy Warhol, who sold himself as a personality in order to market his art, although aspirant geniuses such as Julian Schnabel have followed their master's example by pursuing fame via an energetic policy of self-promotion. Described by one

> 6 *Real painters grunt, like Marlon Brando.* 9
>
> Margaret Atwood, in her novel *Cat's Eye*

critic as 'the Artist as Entrepreneur', Schnabel had already been the subject of exhibitions in Tokyo and throughout America and Europe when in 1987, at thirty-six, he published his autobiography *CVJ: Nicknames of Maitre D's and other Excerpts from Life.*

His friend and contemporary, the Italian painter Francesco Clemente, mythologizes himself through his association with a world drenched in glamorous self-promotion: fashion. He has appeared on the Paris catwalks and in glossy magazines modelling clothes for Comme des Garçons. Rising star Jeff Koons adopts an even more direct approach: his publicity campaign not only includes glossy portrait posters of the artist but also a film, *Made in Heaven*, in which he is seen cavorting naked with the Italian sex-star politician Ilona Staller Fanno, known as 'La Cicciolina'.

It is not as if the current obsession with 'the Artist' can simply be ignored as a diversion and attention returned solely to the art. After all, if art is often now organized around biography, the life inevitably shapes the way we actually see and experience art. Then there is the fact that the authorized version of the history of art can be seen as the history of great male artists – which inevitably tends to isolate the art from the larger social processes of which it is part. Art is often discussed as though it is a window through which one can stare into the artist's frame of mind. In short, the art is presented as a kind of a personal diary of the individual artist which we are privileged to read.

From the perspective of the present, we may be tempted to believe that the current worship of 'the Artist' is a universal obsession, and thus fail to look either for explanations or to imagine a place and period in which things were different. But there was a

*'I want to be as famous as
the Queen of England.'*

Andy Warhol, artist

Francesco Clemente modelling clothes by
Comme des Garçons. Here is the artist as
celebrity, moving among the fashionable.
(© 1988 Timothy Greenfield-Sanders,
courtesy Comme des Garçons)

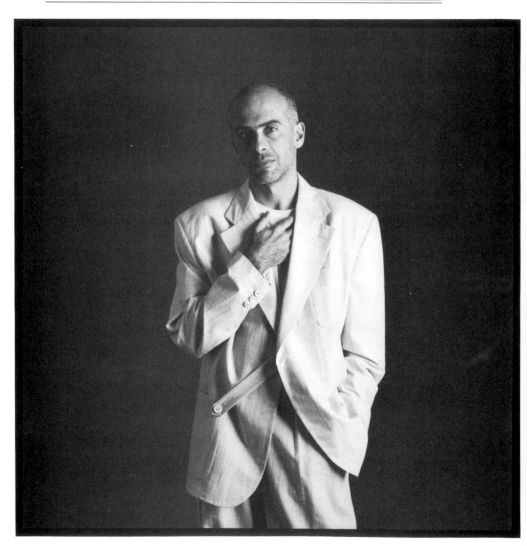

Greek icon of Christ the Pantocrator,
date and artist unknown.
An object of veneration – does it
matter who painted it?

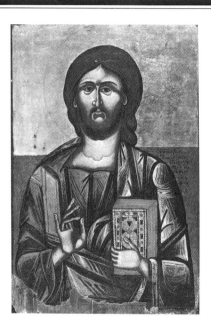

time when priority was given more to an observance of tradition and mastery of technique than to the artist's individuality. Medieval icons, for example, were generally unsigned, and their use of standardized backgrounds and stylistic features acted as devices to exclude the individuality of the artist and enable undistracted religious worship. They stand at the other pole from what seems a quintessentially modern form, the self-portrait, in which the individuality of the artist is supposedly manifest not only in subject-matter, but also in the very brushmarks.

In medieval Europe, painters and sculptors were often just one category of wage-earning artisan who offered themselves for hire

Francis Bacon, *Self Portrait* (1969).
The icon is now of the artist
rather than of Christ.

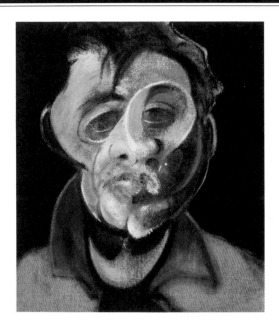

and travelled around the countryside drumming up trade. Medieval
art practice was not subject to today's art historical hierarchies
which differentiate paint and stone from thread and fabric as 'fine
art' and 'applied art'. Up until the fifteenth century these artisan-
artists were usually based in guild workshops or religious orders
from where the clients would order their commissions. The term
'masterpiece' stems back to this time, but its meaning has now
changed. Then it usually meant the final test of skill which allowed
an apprentice full membership to a guild, whether as painter or
stonemason. Now it means a very prized object, the product of the
artist as a Master, someone special, set apart from the rest of us.

*❛Genius is one percent inspiration and
ninety-nine percent perspiration.❜*

Thomas Alva Edison, *Life*

Thamyris painting, from a fifteenth-century edition of *Famous Women
of Antiquity* by the fourteenth-century Italian poet Boccaccio.
Why do we usually assume that the artist is male?

Although 'masterpiece' is a masculine term, the production of
valued art in the Middle Ages was not solely male territory. Both
men and women produced paintings, sculpture, embroidery and
illuminations, whether as part of a household workshop, a religious
order or as a member of a guild. With the spread of the Renaissance
came a reorganization of art practice whereby amateur ecclesiasti-
cal and family workshops were gradually superseded by separate
studios headed by individual 'masters'. It became increasingly diffi-
cult for women of the artisan classes to gain access to conventional
forms of training.

Yet well into the Renaissance, paintings remained bespoke
objects which continued to be organized according to acknow-
ledged and traditional formulae. An artist's handling of colour is
today regarded as an important indicator of personal style and
creativity, whereas the artist of the fifteenth century was bound by

[31]

'Rules and Models destroy Genius and Art.'
William Hazlitt, *On Taste*

long-forgotten rules of colour that affected the execution of a paint-ing and how it was read. Since gold, silver and ultramarine were not just the most precious pigments, but also could be the most volatile – with many different grades and substitutes – patrons were careful to specify in their contracts exactly where and how they wanted their money spent. The 1408 contract for Gherardo Starnina to paint frescoes of the *Life of the Virgin* in the Church of San Stefano at Empoli, near Florence, states that the ultramarine used for Mary should cost two florins an ounce, while for the rest of the picture ultramarine at one florin an ounce would do.

Patrons continued to exercise a close control over their artists even as powerful individuals came to replace the church as the main sponsor of the visual arts and as artists increasingly extricated them-selves from the rules and regulations of the guilds. The contract drawn up between Domenico Ghirlandaio and the Prior of the Spedale degli Innocenti in Florence in 1485 for the panel painting *The Adoration of the Magi*, specifies not only the use of colour and arrangement of figures, but also imposes a heavy penalty of 'fifteen large florins' if the work is not completed on schedule. Artistic free-dom could be even more curtailed. Consider the retainment of Andrea Mantegna by the Gonzaga court in Mantua from 1460 until his death in 1506. They put him to work designing bowls and beakers and lent the artist out to important allies such as the Duke of Milan as a gesture of friendship.

What would now be regarded as demeaning treatment of great tal-ent by Renaissance patrons was then considered to be normal prac-tice. If an artist worked for a patron then the patron often had the last say: for example, there are Michelangelo's disputes with Pope

Julius II over the Sistine Chapel – he was unhappy at being forced to paint rather than sculpt – and Rembrandt's problems with his powerful patron Constantin Huygens in the 1630s. Rembrandt not only had to make stylistic concessions in his five paintings of *The Passion of Christ*, but was also forced to accept Huygens's dramatically reduced payment. And one shouldn't believe that such constraints are a thing of the past. The Mexican artist Diego Rivera was paid in full by John D. Rockefeller who specified the subject and approved the design for Rivera's mural *Man at the Crossroads* of 1932–3; but that didn't stop Rockefeller from forcing Rivera to abandon the project and immediately destroying the mural when Rivera refused to substitute the face of Lenin for that of an unknown worker.

The term 'Artist' only began to emerge in its modern form as a by-product of the Italian Renaissance. The dynamism and social mobility of Renaissance society permitted the (male) individual many more opportunities than the culture of the Middle Ages; and this potential for self-awareness was seized upon by painters and patrons alike. In an increasingly secular society, leading families such as the Medici relied upon the work of leading artists to emblazon their monarchical power, and both sides reaped the benefit.

As artists started to emerge as figures in their own right, their art was viewed differently. Patrons and public began to appreciate an artist's work for its particular style rather than for its adherence to traditional rules of technique and colour. Patrons' contracts begin to attach as much importance to 'skill' as to specific pigments, and to differentiate between the work of a named master and his assistants. The contract for Piero della Francesca's *Madonna della*

Titian, *Charles V at the Battle of Mühlberg* (detail, 1548)

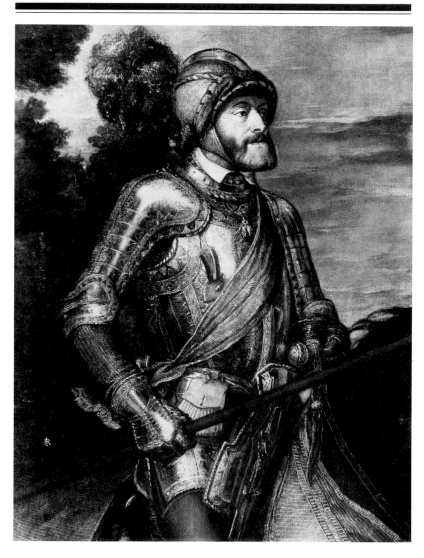

Misericordia, commissioned in 1445, stipulates that 'no painter may put his hand to the brush other than Piero himself'; and just as a contemporary art dealer may now propose a range of artists to a wealthy patron, so in 1490 the Duke of Milan's agent in Florence sent him a memorandum listing the separate qualities of four prestigious painters currently working in the city. He included Botticelli, whose paintings have a 'virile air and are done with the best method'; Filippino Lippi, whose paintings had 'a sweeter air'; Perugino, whose work is 'very sweet' with 'an angelic air'; and Ghirlandaio, who is singled out for his 'good air'. The language of this early form of art criticism may not be the most illuminating (although it has interesting implications in terms of gender: 'virile' and 'sweet'), but it shows that artists were emerging both as individuals and as competitors. More significantly, such early criticism foreshadows the importance that we now attach to an 'original', instantly recognizable artistic style.

With the Renaissance, artists were able to do other than reflect the glory of God. Of course, patrons could be displeased by this: El Greco's innovative version of St Maurice did not find favour with Spain's King Philip II who banished the painting to a remote chapterhouse of the Escorial, his monastery-palace near Madrid, and warned against works of art whose 'beauty inserts itself as an obstacle between our souls and God'. Yet Renaissance patrons did not object to this new valuation of art if it suited their self-image. Philip II and his father, the Holy Roman Emperor Charles V, repeatedly commissioned and praised portraits of themselves by Titian which depicted them not as omnipotent heroes but as vulnerable, pensive individuals.

Opposite above: Hendrik Staben (1578–1658), *Albert and Isabella in Rubens' Studio*
Opposite below: Andy Warhol with (from left to right) Lorna Luft, Jerry Hall, Debbie Harry, Truman Capote and Paloma Picasso at the New York nightclub Studio 54 in 1979.
Both images are evidence of the fact that the artist can enjoy the company of the fashionable and the wealthy.

As the sixteenth century progressed and the jobbing artist-artisan became less the norm, both art and artists became increasingly cosmopolitan and capable of attracting international admiration from princes and public alike. For instance, the German artist Albrecht Dürer was eager to report home the newly-elevated status of 'the artist' that he discovered when visiting Italy. In 1506 he wrote from Venice to a friend in Nuremberg: 'Here I am a gentleman, at home I am a parasite.' Fifteen years later he was the toast of the court of Charles V. Instead of trying to aspire to the class of their patrons, artists began to realize that they could form a new international class of their own.

From the Renaissance onwards, fame has become an increasingly important consideration for certain categories of artists as well as for patrons. It is wrong to assume that current art celebrities such as Schnabel, Clemente, and the 'father' of them all, Warhol, are deviations from the norm of the artist as poor outcast, or, indeed, that celebrity status is necessarily inimical to great art. According to a contemporary source, Raphael, now recognized as one of the great artists, 'lived more like a prince than a painter' and even commissioned the celebrated architect Bramante to build him a lavish Roman palace.

The history of Gianlorenzo Bernini's relationship with Louis XIV, who invited the sculptor to Paris in 1665 to redesign the Louvre, illustrates the star status an artist could enjoy. During his journey from Rome to Paris he was treated more as a prince or a hero than an artist. In every city crowds lined the streets to catch a glimpse of the great man and he was fêted en route by noble families, from the Medici to the Duke of Savoy. All this culminated in an

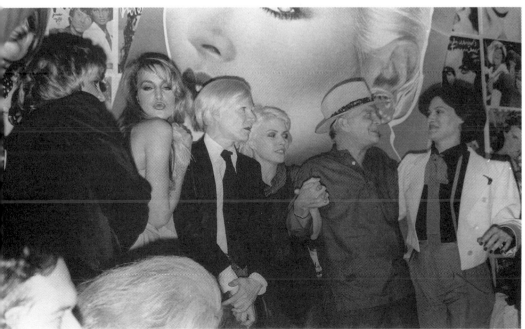

Gianlorenzo Bernini, *Louis XIV* (1665).
Valued as much as a sculpture by Bernini
as a portrait of the Sun King.

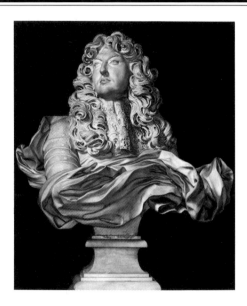

official reception in the King's name at the French border and the
ceremony was repeated at every stop on the way to Paris. Yet such
was Bernini's confidence (or arrogance) that he soon made enemies
by his repeated refusal to pay homage to the court or to the country
in which he was a guest. This imperious attitude meant that he
returned to Rome after just four months with the Louvre project
abandoned and just one royal portrait bust completed.

So great was Bernini's reputation, however, that he suffered no
ill-effect from this episode, and by the end of both his and Louis'
lifetimes, and up until the present day, his bust of Louis XIV has
been admired as much as a sculpture by Bernini as a portrait of the
Sun King. By this time, the meaning of a masterpiece had changed

from a guild test of professional credentials to a magnificent work in the history of a great artist.

The idea of the Artist-Celebrity is perhaps especially indebted to one publication: Giorgio Vasari's *Lives of the Most Eminent Painters, Sculptors and Architects*. First published in 1550, and then in a revised and enlarged edition, complete with portraits of the artists, in 1568, this lengthy study combined exhaustive biographical anecdote with critical comment. It immediately overshadowed Vasari's own achievements as an artist and architect to make him the doyen of the Italian art world – he was even knighted by Pope Pius V in 1571. But more importantly, Vasari's *Lives* not only sets out a checklist for what constitutes artistic 'genius', but also forms a crucial landmark in establishing our contemporary image of the artist as a personality, with a life and career that merit as much scrutiny as the artist's work. Still widely read today, the book is the ancestor not simply of the artist's monograph of today, but of those Hollywood and television biopics which have shaped the popular imagination.

No 'Old Mistresses' command the same semi-sacred status accorded to certain male artists by Vasari; and the term has connotations very different to those of 'Old Master'.

Although Vasari's *Lives* did discuss the women artists of the Renaissance, he established a pattern taken up by subsequent practitioners of art history when not only did he make women artists a tiny minority, but also ensured that they conformed to the social expectations and duties ascribed to their sex. In his chapter on the sculptor Properzia de' Rossi, Vasari makes a point of emphasizing that she was accomplished in household management, beautiful in body and a better singer than any woman in her city, before he

❛*So long as a woman refrains from unsexing herself by acquiring genius let her dabble in anything. The woman of genius does not exist but when she does she is a man.*❜

Cited in Octave Uzanne, *The Modern Parisienne*, 1912

Toulouse-Lautrec and his model in front of one of his paintings of brothels, *Au Salon* (1893). Men make art and women are its objects – or so it has too often been assumed.

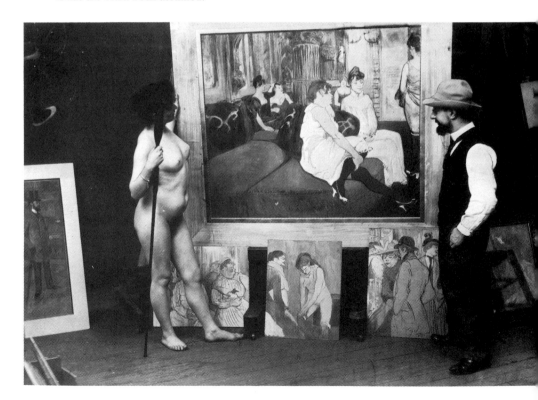

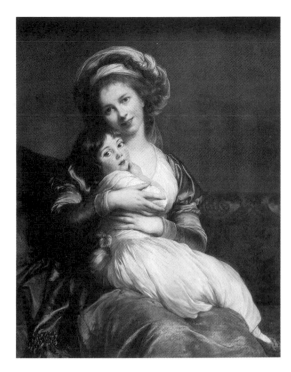

Left: The artist as mother. Louise Elisabeth Vigée-Lebrun, *Portrait of the Artist with her Daughter* (1769)
Below: Angelica Kauffmann and Mary Moser, the Royal Academy's two female members, are relegated to portraits on the wall of Johann Zoffany's *The Academicians of the Royal Academy* (detail, 1772), as it was deemed unseemly for them to be portrayed looking at a naked man.

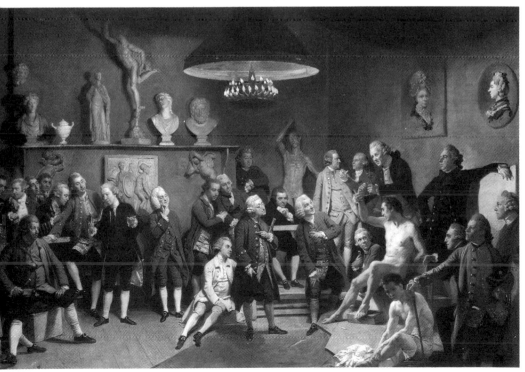

finally reveals that she was a skilled carver. Even then it is her subtlety, smoothness and delicate manner that he praises, distinguishing her work by its 'womanly grace'. This kind of representation has dogged women artists up to the present day.

As art production became and remained the activity of individual greatness it became established as male territory. From the emergence of the powerful, autonomous Renaissance artist, whose highly organized workshops denied women the framework in which to train and work (unless they were born into the nobility or from a family of painters), to the barring of women from the academies and life-classes in the eighteenth and nineteenth centuries, prejudice and practical obstacles ensured that women remained on the periphery of art. Even if they did become artists, women were discouraged from producing the historical, religious and classical subjects that were considered to be 'serious' art and the only recognized vehicles for artistic genius.

Vasari was also crucially important in establishing patterns of language for valuing 'the Artist' which are echoed in contemporary valuations and which are structured around sexual difference. The last and longest entry in the *Lives* was reserved for Michelangelo who is eulogized as an artistic messiah, 'skilled in each and every craft' and chosen by 'the benign ruler of heaven . . . to save us from our errors'. This belief in the genius as a godly figure with divine talents is distinctly male, since women have not been seen as the messiahs but rather as mothers or (in artistic terms) as muses.

But Vasari's terms of praise for Michelangelo at least stressed his craft skills and thus the importance of them in defining 'the Artist' as much as his specialness as a man. The artist's significance as a

❛So do I believe that works of genius
are the first things in this world.❜
John Keats, 1818

person remains inseparable from what he creates. However, in the late eighteenth century there was a profound shift in emphasis as the skill of the painter became of much lesser importance than the exceptionality of 'the Artist'. A real gap was established between the artisan who was a man with certain skills and 'the Artist' who had creative or imaginative purposes. With the decline in the system of direct patronage and the diminishing reputation of the academies, artists were abandoned to the market where the art object was valued solely according to the price it could attain. The artist became just another seller of wares. As their products were useless in utilitarian terms – Jeremy Bentham said 'push pin was as important as poetry' – artists claimed for themselves and their activity a superior status which judged the society that no longer needed them.

Whereas the artists of the Renaissance, however high their standing, had maintained workshops and worked to order from their patrons, the isolated Romantic artist of the nineteenth century was driven back on his own resources, forced to draw on his own imaginative powers to produce work which the public might or might not want. In a world of increasing mass production, where it became possible for the first time to reproduce images cheaply on a large scale, it is no wonder that the artist was driven to celebrate 'originality', which is what separated him from both the 'talented' artist and the common herd. Imitation, which was once a valued artistic activity, now became a sign of inadequate artistic skill. It was around this time that the word 'fake' in its modern meaning entered the English language.

But this insistence that the artist was special, with imaginative powers and a rich inner life beyond our own, could easily translate

Henry O'Neil, *The Last Moments of Raphael* (1866).
The Old Masters emerged as idealized heroes in
the paintings of nineteenth-century artists – the
forerunners to the Hollywood bio-pic?

into terms that make 'the Artist' not simply outcast but madman.
The prototype of this Romantic artist, at least within Britain, wasn't
in fact a painter but the boy-poet Thomas Chatterton who commit-
ted suicide in 1770 at the age of seventeen. His death acted as a
trigger for the Romantic imagination well into the nineteenth cen-
tury. As well as inspiring eulogies from Keats and Wordsworth,
Chatterton was also a hero of the Pre-Raphaelites, praised by
Rossetti and most famously celebrated by Henry Wallis in his paint-

*❛The paintings by dead men who were poor most of
their lives are the most valuable pieces in my
collection. And if the artist really wants to jack up
the prices of his creations, may I suggest this:
suicide.❜*

Kurt Vonnegut, in his novel *Bluebeard*

ing *Death of Chatterton* which needed the protection of two police-
men to hold back the crowd when it was unveiled to the Manchester
public in 1858. The paradox was that the outcast became market-
able, an object of interest, even of reverence. If the artist was other
than us, had powers beyond ours, brought to us values which could
be found nowhere else, then maybe he wasn't so much a madman as
a Christ-like martyr.

The most famous example of the martyred artist is Vincent Van
Gogh. Since his suicide in 1890 a flourishing Van Gogh industry has
grown up, via books, films, documentaries and articles, to ensure
that he is not just the world's best-known artist but that the figure of
Van Gogh has become a synonym for the tortured, struggling genius.
In spite of an abundance of information about Van Gogh, fact and
fiction have blurred to turn his life into a series of lurid myths. It is
largely upon these carefully cultivated myths that his popularity
continues to rely. And yet one has to remember that the myths were
themselves born out of certain historical conditions which forced
artists to assert their specialness in the 'desolate market where none
come to buy'.

The publication of Irving Stone's *Lust for Life* in 1935 effectively
marked the beginning of the great popular cult of Van Gogh.
Although both the book and Vincente Minnelli's film of 1956 were
produced with a conscious respect – bordering on reverence – for
their subject, they both emphasize what was the animating force of
the Van Gogh (and the tragic genius) industry: the artist's insanity.
From the eighteenth century onwards a close interest in the artist's
sensibility had resulted in as much attention being paid to the
behaviour surrounding the creation of art as to the work itself; and

Kirk Douglas as Vincent Van Gogh, with *Crows over the Wheatfield* on his easel, just before he shoots himself in the film *Lust for Life* (1956).

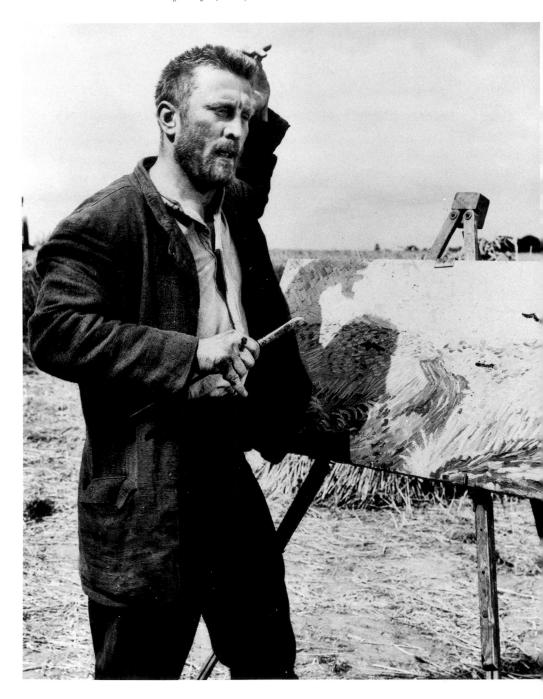

❝Now I understand
What you tried to say to me
How you suffered for your sanity
And how you tried to set them free
They would not listen, they did not know how
Perhaps they'll listen now.❞

Don McLean, 'Vincent'

the events of Van Gogh's life, the characteristics of his work, his legendary self-mutilation and his suicide, all provided material to be reworked into the now-familiar theme of the madness of the artist.

But this is a madness with a message. In Minnelli's film, just before Van Gogh kills himself, he spreads his arms across the tree as Christ, the Man of Sorrows. The Artist's madness is not just any old person's madness. Van Gogh's supposed insanity is perpetually presented as his motivation, his sole source of torment, the symbol of his struggle and the symptom of his genius.

One of the first critical essays on Van Gogh, written by Albert Aurier in 1890, just before the artist's death, lists most of the criteria for tragic genius when it declares 'he reveals himself as powerful, a male, a daredevil, frequently brutal and sometimes ingenuously delicate. . . a sort of drunken giant, a terrible and maddened genius'.

Much of the popular appeal of Van Gogh's paintings lies in their subsequent interpretation in terms of his despair and self-destruction. At the climax of *Lust for Life*, Kirk Douglas is shown abandoning the painting *Crows over the Wheatfield* and shooting himself in front of this painting. It is not simply that the identification of the painting with his ultimate 'mad' act has been refuted by the discovery that the painting was not his last will and testament: he had actually stopped working on it some time before his last suicide attempt. What such a collapse of art into biography also does is to obscure how much the depiction of the wheatfield owes to Dutch landscape painting and Van Gogh's desire to demonstrate the wholesome effect of the country to his brother Theo. In a letter accompanying this and two other canvases, Vincent wrote to Theo:

[47]

❝The world demanded that he give; the demons demanded that he take back . . . He veiled his art just as he veiled his life, to protect himself from the world without and the terrors within.❞

Steven Naifeh and Gregory White Smith, *Jackson Pollock*

'I almost think that these canvases will say what I cannot say in words, the health and restorative forces that I see in the country'. Often the myth can distort history and, as is clear here, it can influence our reading of the painting.

This biographical framework fails to recognize that to create the painting Van Gogh had to engage in certain artistic conventions. It is a myth that the painting is simply an expression of his emotional state. And this biographical distortion is not restricted to art-historical ingénues. In an essay on Van Gogh's *Starry Night*, Lauren Soth, a leading Van Gogh authority, can say that the painting 'is Van Gogh's agony' (the Christ analogy again).

Even the judgement of what counts as an important, 'typical' Van Gogh painting has been governed by our hunger for biography. There is a relative indifference, for example, to the early genre painter Van Gogh; while the late Van Goghs, with their vigorous brushstrokes, are seen as expressive of the painter's tortured mind. According to this myth each stroke can be read as a sign of the individuality of the artist.

It is precisely this adoration of expressive brushstrokes which contemporary artists have to live and work with – or against. An interesting aspect of the generation of famous German artists that includes Georg Baselitz, Anselm Kiefer and Jörg Immendorff is its relationship to the idea of the Romantic artist. The work of these artists, with its expressive brushwork and tortured subject-matter, seems to continue in the tradition of the angst-ridden artist. In his life as well as his art Baselitz, with his shaven head, scarred face and Roman mastiff dogs, seems to be the alienated outsider. But these artists have not suffered the fate of those of earlier generations –

Jackson Pollock at work in his studio
in New York in 1950

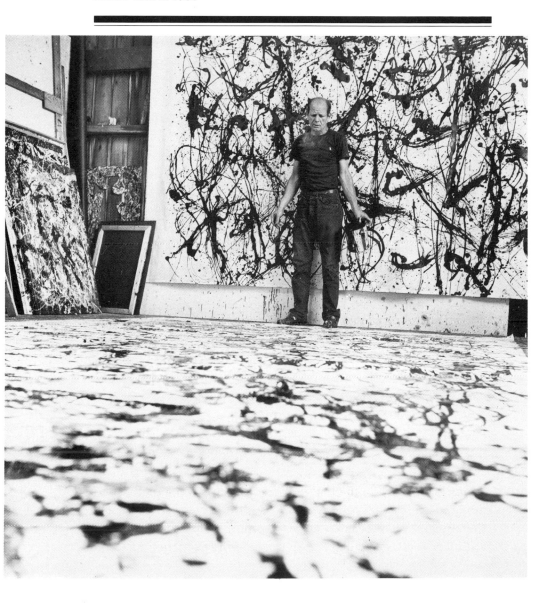

Roy Lichtenstein,
'Big Painting Number 6'
(1965; Brushstroke series)

Baselitz lives in a castle, Kiefer's assistants ride bicycles to get around his vast studio – but they have nevertheless been able to sell the image of the Romantic artist to the market. Suffering has become saleable.

Other painters have viewed the worship of the expressive tradition with a more jaundiced eye. The Pop artist Roy Lichtenstein parodies the expressive painterly gesture in his flatly painted, comic-strip Brushstroke paintings. More importantly, a comprehension of Andy Warhol's work is impossible without an awareness of how he played with and distanced himself from the activity of the Romantic genius. His work (and particularly the self-portraits) combines the mechanical anonymity of the silkscreen with thick luxurious brushstrokes, setting up signs of expressiveness and simultaneously cancelling them. In his *Oxidation* series of paintings Warhol even went so far as to urinate directly on to the canvas. If art is the personal mark of the artist then Warhol debunked it by writing the ultimate signature. His passivity and his visible lack of suffering were his playful way of distancing himself from the legacy of the suffering, passionate, brush-wielding Romantic genius. Warhol's reaction to a near-fatal assassination attempt was to have his scarred torso photographed by Richard Avedon.

Warhol may have been an androgynous dandy who played with the masculine myth of the genius and who mocked the popular theory that the paintbrush was an extension of the penis, but he was still a man. Although his homosexuality may have helped him to stand outside the dominant definition of the artist as potent male, his irreverent gestures made no concessions towards women artists. Warhol's Marilyns and Liz Taylors remain the passive pin-ups of art

[50]

Cindy Sherman, *Untitled Film Still*,
photograph (1979)

history. Women artists have been seen to be no competition for the
celebrated and tortured male geniuses: until recently Gwen John
was simply Augustus John's neurotic sister and the jilted mistress of
Auguste Rodin; just as Georgia O'Keeffe was the eccentric wife of
Alfred Stieglitz. A woman was never an insane genius, she was just
insane.

It is not surprising that many women artists of today, rather than
trying to adopt the mantle of 'the (male) Artist', are making a point of

*❝To encourage a dispassionate, impersonal,
sociological and institutionally orientated approach
would reveal the entire romantic, élitist, individual-
glorifying and monograph-producing substructure
upon which the profession of art history is based.❞*

Linda Nochlin

challenging its assumptions – even to the point of rejecting paint as
the obvious medium of art. The American artist Sherrie Levine's
photographs of Walker Evans' classic photos documenting the
effects of the Depression in the American South, British artist Rose
Garrard's gun-framed paintings, Americans Jenny Holzer's and
Barbara Kruger's choice of mechanical 'anonymous' media – graph-
ics, billboards and flashing electronic signs – all this work opposes
the paraphernalia of the male Romantic artist. Perhaps this is most
clear in the dramatic photographic 'self-portraits' of the American
artist Cindy Sherman in which she stages herself as women
stretching from Marilyn Monroe to representations of women in
nineteenth-century painting. Rather than expressing herself in
her work, Sherman plays with and denies the idea of any stable
continuous self which exists beyond discourse. For such an artist
the 'self' is conspicuous by its absence.

But it should be clear that the shifting valuations of the artist are
part of a wider history and cannot be overturned simply by an indi-
vidual artistic will such as Sherman's. As things were once different,
they may become so again. What a sketch of the history of the artist
shows at least is that as the idea of 'the Artist' changes, then so does
the kind of work that is produced, who is allowed to do that work
and how it has been valued. The painter or sculptor may be the
person who has always done the deed, but 'the Artist' is something
else again.

2

The Colour of Money

The art market is not new, but its status as a popular spectator sport is. The price of art attracts more public attention than any other commodity – except perhaps oil. National newspapers carry regular art market columns, while price fluctuations are closely followed and passionately debated by those both inside and outside the business. Exceptionally high sums attract wide media coverage together with a public response that ranges from outrage and ridicule to admiration.

The orthodox view is that this situation is not only new but bad; that once art was not subject to financial speculators, and that the price it fetched was more in keeping with its value. Yet even the most cursory look into history shakes that orthodoxy. Holland in the seventeenth century was a rich and powerful imperial nation which, like Japan now, traded and speculated in art. John Evelyn, the seventeenth-century diarist, records that it was quite usual to find Dutch farmers paying the equivalent of up to £3000 for paintings and then reselling them at 'very great gaines'.

Other countries in Europe, however, still relied on state or private patronage and were less used to considering art as a commodity to be traded. But even within the older system the financial implications of art could be active in patrons' minds. When the collection of the Duc d'Orléans was sold in London in 1798, a major proportion of his paintings (which included works by Titian, Poussin, Raphael and Velázquez) was bought by a group of noblemen for £43,000, apparently as an investment. Keeping the best pieces for themselves, they later resold the remainder for more than they had originally paid for the entire collection. Even painters themselves, most notably Titian, were not above dealing in art.

'The art of making art
Is putting it together –
Bit by bit –
Link by link –
Drink by drink –
Mink by mink –
And that
Is the state
Of the Stephen Sondheim
Art!' *Sunday in the Park with George*

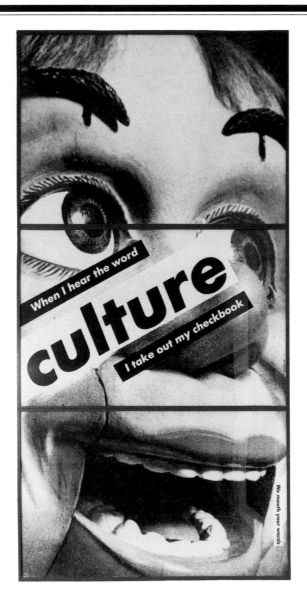

Opposite: Barbara Kruger, *Untitled* (When I hear the word culture
I take out my checkbook), photograph (1985)

Below: Picasso's *Au Lapin Agile* goes under the hammer
at Sotheby's, New York, on 15 November 1989 for
$40.7 million (£25.7 million).

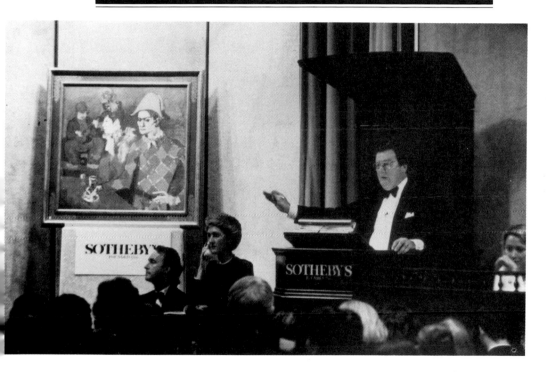

It would be entirely wrong, then, to assume that money was a
recent arrival in the art world. What now defines the contemporary
art market, and distinguishes it from earlier ones, is that it is a global
market and recognized as such by the players. The most visible sign
of this is at a major auction. It may take place in New York, but the
telephone bidders are as likely to be in Lausanne and Tokyo as in
the body of the auction room. At a recent auction of an important
Picasso in Paris the event was beamed live by satellite to Tokyo in
order to facilitate Japanese participation.

A Christie's sale in progress,
by the eighteenth-century
caricaturist Thomas Rowlandson

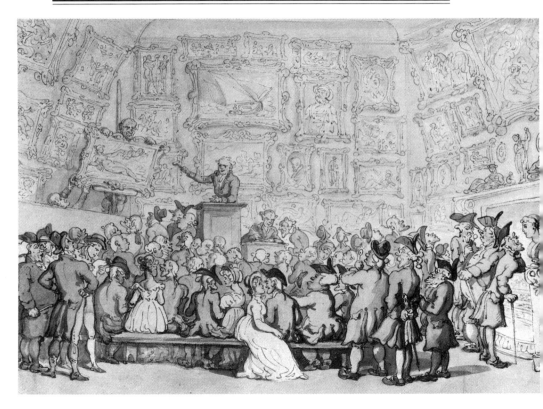

Globalization is no less visible in the world of the dealers. Major
London gallery owners such as Anthony d'Offay and Nicholas
Logsdail of the Lisson Gallery have recently said that they don't see
themselves as part of the London or British art world, but as part of
the global one. Anthony d'Offay declares that he may see his friends
and clients from Cleveland, Ohio, more often than he sees those
from his home city. For him the opening of Eastern Europe to

> **‹It is a well known melancholy truth that the tribe of auctioneers, connoisseurs, picture dealers . . . have monopolised the trade of pictures, and made it a matter of ridicule to purchase any modern production, or encourage an English artist. By this craft the leaders of taste of these kingdoms acquire fortunes and credit, whilst many of our painters, men of genius and industry, are absolutely starving . . .›**
>
> Letter in *St James's Chronicle*, 25 April 1761

market forces is something to be embraced. He fully expects to be showing artists from Eastern Europe, Japan, and the Third World in the next ten years, as well as the Western European and North American artists he shows at present.

The difficulty with trying to assess the importance of the art market in bestowing a value to art is to know how much importance to give to the first word, art, and how much to the second word, market. At one level, after taking into account its special sales requirements, the art market can be seen as no different from any other marketplace with just another kind of commodity to sell. And there is no doubt that the auction houses in particular have pursued money with fervent seriousness.

The word auction derives originally from the Latin *augere*, to increase, and the first auctions were reputedly held directly after battles to divide up the spoils between the highest bidders. But it was not until the eighteenth century, when the system of direct art patronage was in decline and artists began to group themselves around the academies, that art dealers stopped being antiquarians and the auction house, as we know it, began to emerge. The first regular auction room was 'The Vendu' which opened in Covent Garden in 1690; in 1766 James Christie established his firm, which soon became London's principal auction house for fine art. Although Sotheby's had been operating in the Strand for several years before Christie's, the rivalry between the two houses only began in the present century since it was then that Sotheby's stopped restricting their business to books, manuscripts and classical antiques and began their rise to the head of today's art market.

To court the potential big spenders, today's auction houses have

Opposite: Japan now enjoys a reputation as an art-consuming
nation. Even the giant Seibu Department Store in Tokyo
houses three art galleries.

adopted new and non-traditional policies to broaden their business
base.The year 1966 marked the first publication of the *Time/
Sotheby's Art Indexes* which purported to give reliable statistics on
the price movements of a range of artworks. Short, sharp and illus-
trated with graphs, they de-mystified art investment and made it
seem as logical (or illogical) as any other investment. They also
encouraged new investors by showing that every form of art was
going up in value.

Sotheby's, under its new owner, the American real estate
magnate A. Alfred Taubman, who bought it in 1983, initiated a
campaign to attract big money. The new target customers were
America's (and more recently Japan's) rich and sophisticated busi-
ness sector which had not previously dealt with salerooms. Not only
did these new clients take the bait, they have changed an old market
tradition. Collecting patterns, which had in the past been character-
ized by purchasers showing a long-term, gradually increasing
financial commitment, have been rapidly turned upside down by a
new breed of buyer who can often spend over £1 million on a first
purchase at auction. At Christie's in New York in May 1988 the Jap-
anese purchaser of Franz Kline's *August Day* (1957) bid up to
$2.75 million, having only learnt of the artist's existence a week
before.

It's worth adding that the Japanese consumption of artworks is
greatly assisted by an abundance of cheap credit made available by
Japanese banks for corporate art investment. In Japan such invest-
ment is a serious business. The Tokyo conglomerate Aichi Corp not
only controls the high-spending Aska International Gallery, but in
September 1988 became one of the five largest shareholders in

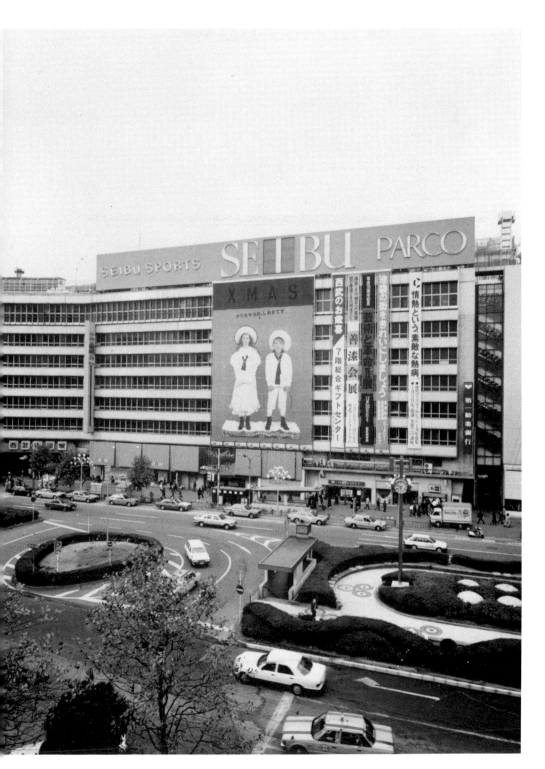

Christie's, with a 6.4 per cent stake. To lubricate the business passing through their salerooms, auction houses have taken the unprecedented step of adding banking services to their repertoire. Taking the lead from the success of the *Time/Sotheby's Art Indexes*, Taubman realized that if the salerooms were to flourish in the ruthless habitat of the late twentieth century, then they needed to adopt some of its business methods. From the time of his takeover, Sotheby's Financial Services division began to offer loans and credit schemes. Initially organized on an informal level, these were quickly extended to include any credit-approved individual selling goods valued in excess of £16,000 or simply borrowing on the strength of assets valued at a minimum of £150,000. Sellers were also given a strong inducement by the common practice of issuing guarantees that a work of art would realize a specified price at auction, and if this was not achieved then the customer would receive the guaranteed amount while the auction house retained the work for later sale.

This policy has been lucrative but precarious. By the end of 1988, Sotheby's had changed its business to such an extent that its lendings and other investment services generated $240 million, nearly a tenth of its gross income of $2.3 billion. But the sortie into the world of speculative money-lending also had its hazards. When the Australian businessman Alan Bond paid Sotheby's New York the record-breaking $53.9 million (£30.2 million) for Van Gogh's *Irises* in November 1987, the purchase was made possible by a loan from Sotheby's of half the purchase price, using the value of the painting as collateral. This action was widely criticized throughout the art world for fuelling an artificial boom in art prices. Following

rumours that Bond was having trouble repaying the loan, Sotheby's announced in January 1990 that they would no longer lend money against paintings being bought. While Christie's and the smaller auction houses offer neither loans nor guarantees, they have nevertheless reaped the benefit of the inflated prices generated by these practices.

Commercial galleries cannot compete either with the high profile or the financial resources of the auction houses, but like them they are places of trade where it is possible to buy a particular kind of commodity. They employ staff, audit accounts and control their stocks in ways not dissimilar to other retail outlets. A new law in New York has recently eased galleries towards the category of a shop by insisting that art galleries display price tags on their merchandise.

But the problems of trying to analyse sectors of the art market as though they were identical to all other markets is clear when one asks the following questions: does the art market treat art like any other commodity, or are the commodities with which the market deals converted into art by the process of the market?

That the second question may be more pertinent than the first, or at least equally relevant, is signalled by the auction of the Warhol Collection by Sotheby's in New York in 1988. The collection ranged from paintings and furniture to cookie jars and all were catalogued and displayed at previews in the manner of artworks. Leading art collectors battled furiously at the auction where Warhol's collection of 145 cookie jars alone was sold for $113,000.

The argument cannot rest just upon the possessions of Andy Warhol since the occasion was unique. But there are plenty of other

The art market lusts after originality. Artist Allan
McCollum mocks this desire in a 1989 installation
of his *Plaster Surrogates* (1982) which presents over
a thousand different versions of a blank framed 'picture'.

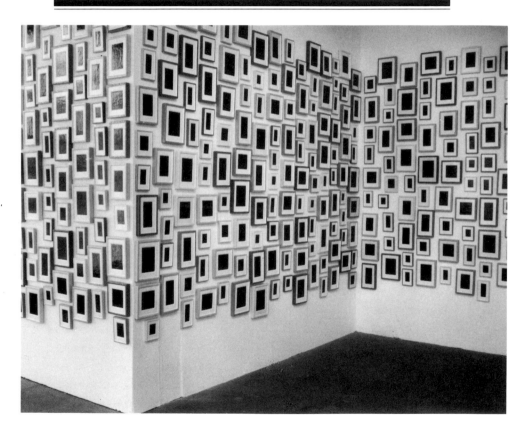

examples to show how the art market alters our perception of art.
Think how the standing of an artist relegated to the level of a histori-
cal curiosity can be revised in the light of significant sales at auction.
Or how the reputation of a contemporary artist can soar after a sale
at auction, or how works, not made as art objects, can be marketed
and sold as such (works, say, from non-Western societies). This is

*❛Art is sexy! Art is money-sexy! Art is
money-sexy-social-climbing-fantastic!❜*
Thomas Hoving, Director,
Metropolitan Museum of Art, 1967–77

not to say that other factors do not shape market judgements. For
instance, it seems likely that the six major exhibitions devoted to
Van Gogh in the 1980s helped the artist's market price. But there
can equally be little doubt that the market profile of artists boosts
the critical attention given to them. In short, the art market does not
merely sell art commodities but actively helps to define what counts
as art and particularly what is 'significant' art.

When an artwork is sold, it is sold not simply as a commodity but
as something else. Whether it is a white-walled, white-hot, up-to-
the-minute contemporary gallery, or a heritage-laden, leather-
upholstered Old Master dealer, or a glamorous auction house in one
of the metropolises of the world, each establishment promises its
clients much more than a painting to hang above the mantelpiece –
it guarantees access to a particular way of life. And it is this, as much
as the commodity, that the art market sells its clients. (Significantly,
they are never called customers.)

The new-look auction house has transformed the very nature of
art sales. Money – big money – is clearly important, but the serious
money simply adds further cachet to an already glamorous occa-
sion. Important auctions are now exclusive gala performances with
winning bids receiving a standing ovation from an audience in black
tie and jewels. Certainly, during the eighteenth century, it was fash-
ionable for the leading figures of the day to be seen buying art at auc-
tion houses – James Christie was a close friend of Reynolds,
Garrick, Gainsborough (who painted his portrait) and Sheridan, and
they all attended his sales. But these were small parochial affairs
compared to the glamour and spectacle of today's most prestigious
auctions. The painting is now the star of a dazzling show where the

[63]

A
CATALOGUE

Of all the GENUINE

Houshold Furniture, &c.

OF HIS GRACE

James Duke of Chandos,

Deceas'd,

At his late Seat call'd CANNONS, near *Edgware*, in *Middlesex*,

CONSISTING OF

Rich Gold and Silver Tissue, Brocade, Velvet, Damask, Chintz, and *other beautiful Furniture,* in Beds, Hangings, Window Curtains, Chairs and Settees.

An exceeding fine Set of TAPESTRY, *made at the* GOBELINS; Glasses of all Sorts, in the most magnificent Taste; several rare Pieces of JAPAN, in *Cabinets, Chests, Screens,* &c. TABLES of *Oriental Jasper,* fine *Italian* Marble, &c. Gold, Needle-work, and *Persia* Carpets. Great Variety of curious Walnut tree inlaid *Book-cases,* with Looking-Glass Doors.

A most matchless Piece of carving, in Alto-Relievo, of the Stoning of St. Stephen; by the late famous Mr. Gibbons. A Collection of *Mathematical Instruments.* A fine Set of Cartoons, by RAPHAEL URBIN; and *Academy Figures* by MICHAEL ANGELO. Two large and exquisite fine *Battle-Pieces,* by WYCK. An exceeding fine ton'd ORGAN. Two Marble Figures bigger than the Life, cut at *Rome,* of the *late Queen Anne,* and the *Duke of Marlborough.* A large Billiard Table, and other valuable Effects.

Which will be Sold by AUCTION,

By Mr. COCK,

On *Monday* the 1st of *June,* 1747, and the ten following Days, at CANNONS above-mention'd.

The Furniture, &c. *may be view'd on Wednesday the 27th, and every Day after (Sunday excepted) to the Hour of Sale, (which will begin each Day at half an Hour after Eleven precisely) by all Persons who shall produce a Catalogue of the said Furniture, which may be had at One Shilling each.*

CATALOGUES *may be had at Grigsby's Coffee-House,* behind the *Royal Exchange;* at the *White Hart,* in *Watford;* the *Three Pigeons,* in *Brentford;* at either of the Lodges leading up to *Cannons,* from *Stanmore,* or *Edgware;* and at Mr. COCK'S, in the *Great-Piazza, Covent-Garden.*

*‘Tomorrow we go to the big new show
by Monet or Manet or Money
or some such guy.’*

Martin Amis, in his novel *Money*

Opposite: Note the relegation of
the art to the third paragraph in this
eighteenth-century auction catalogue.

drama is heightened by the enigmatic presence of telephone bidders from across the world. The magazine *Vanity Fair* described a recent painting for auction, Picasso's *Au Lapin Agile*, as one of 'hopeless love, suicide and a contested will', for all the world as if it were the plot of a forthcoming feature film.

But it is not all showbiz. While the ability of the museums to buy art has been damaged by the kinds of sums that are paid by collectors at auctions, the auction houses have increasingly appropriated museum habits to dignify their own processes, and to make it clear that they are something more than clearance houses. The recent museum policy of mounting 'blockbuster' shows (for example, late and early Cézanne, Van Gogh, Degas, Watteau, German, British and Italian art in the twentieth century) which travel worldwide, is paralleled by the auction house practice of taking a single painting, or the highlights of an important collection, on an international tour prior to the sale.

Since the 1980s these preview exhibitions have proved a valuable public relations exercise and an important ingredient in raising the international profile of the auction houses as well as attracting the interest of buyers. Expertly hung and accompanied by glossy, scholarly catalogues, they evoke the authority of a museum exhibition but with the extra excitement of an impending sale and the promise of record-breaking prices. Additional interest is also generated by the possibility that this may be the last chance to see the works before they vanish into the bank vaults of new owners. Christie's three-month tour of Van Gogh's *Sunflowers* to New York, Paris, London and Japan in 1987 attracted wide press coverage and also played a significant part in its acquisition by a Tokyo insurance

> *6Marketplaces . . . can be hotbeds of human exchange and interaction. They can be sites of pleasure and passion, sources of anarchistic energy. In our culture, the pleasure of this anarchy is reserved for the few. So when we set art against commerce, we distort both. . . . To define art as a "spiritual" activity, and then to deny human commerce any spiritual value, well, that's ludicrous.9*
>
> Allan McCollum, artist

company for the then record price of £24.75 million in March 1987.

The touring of works is now a standard marketing procedure and has become a key factor in the competition between auction houses to handle a client's collection. As a rule, who tours wins. If the owner is already well known then individual estates coming up for auction are given additional promotion as 'single owner' sales with every attempt made to ensure that these events carry the cachet of their sources. This is not new. The sale of the Duc d'Orléans' pictures was enhanced by their connection with the French royal family (the collection had been largely assembled by Philippe II, Duc d'Orléans, Regent of France after the death of Louis XIV); and one of the eighteenth century's most important auctions was the Desenfans Collection assembled by art dealer Noel Desenfans for Stanislas II, King of Poland, and sold at Christie's in 1786. The more recent record prices achieved by Florence Gould's Impressionists, Robert Scull's Pop Art, Edward James's Surrealists, Victor Ganz's Picassos or Andy Warhol's memorabilia show that collectors continue to assist the art market not just by making purchases but by valuing provenance and attaching a unique mystique to artworks. The sophisticated marketing skills employed by auction houses take full advantage of all these factors.

With their vast resources, the auction houses are now increasingly accused of challenging the other main factor of the art market: the dealers. The relationship between these two branches of the art market is a complex one. The auction houses may be increasingly adept in encouraging people to buy and sell directly through the salerooms, but the majority of fine art purchases made at auction are

still to the trade. When they choose to buy a work from an auction house, most collectors still prefer to use a dealer as their agent in the gritty business of bidding; and the dealer always receives a commission for this service.

Some dealers declare that they have benefited from the art market boom and the marketing strength of the auction houses, while others feel that escalating saleroom prices have left them with a narrower margin for resale. Widely acknowledged, however, is that at the selling end many dealers have lost out to the renovated auctioneers. Tempted by the prospect of large international audiences and the prominent touring of works, more people are now encouraged to sell their artworks through the auction houses, whereas they may still rely on the judgement of their dealer in making a purchase. Auction houses, therefore, compete fiercely with the major dealers as well as amongst themselves to handle the sale of an important work or collection. But in whatever way the dealers are affected by the recent auction house boom, their share of the art market is still enormous. Each type of dealer, whether specializing in Old Masters or contemporary art, employs very specific methods to retain his or her role in today's market.

The sober Old Master establishments blend the aura of a museum with that of a select gentlemen's club; and this air of authority is deemed appropriate to the accumulated gravitas of the merchandise. It is also important in fostering the intimate dealer-client relationship that is a central part of the Old Master dealer's sales technique. Such dealers in Old Masters are accomplished at promoting themselves as a profession, not a trade; and they encourage their clients to feel part of a privileged élite which is capable not

*❝Perhaps the Japanese will realise one day
that many knowledgeable Westerners
are smiling behind their hands at
the prices the Japanese are paying.❞*

Kevin Sullivan, *The Guardian*, 17 May 1990

only of affording but also of appreciating and taking on the responsi-
bility of owning a fine artefact from the past.

It is interesting to note that the 'first art dealer', Jacopo Strada in
the sixteenth century, offered classical art and treasures to Euro-
pean princes rather than contemporary work. It is almost as if art
with an illustrious pedigree is a secular version of the holy relic,
something which will put its owner in touch with the divine.

Exhibition openings at Old Master galleries tend to be select pri-
vate parties primarily for clients, with uniformed staff serving fine
wines and canapés to pinstripe-suited guests. Some dealers can
offer not only a lengthy provenance for the works they sell but can
also provide a lengthy one for themselves. The Old Master dealer
Thomas Agnew & Sons, for example, was established in 1817.

The last twenty years has seen the clientele for Old Masters
dramatically expand from predominantly European and American
collectors to include the Japanese who now buy Old Master paint-
ings and drawings from both salerooms and dealers. The arrival
of this powerful element into the art market in the late 1960s, and
its rapidly escalating presence throughout the 1980s, was an im-
portant factor in enlarging the art market from an international to a
global enterprise. From Rembrandt to Renoir, Japanese customers
now buy big names in bulk. They still show a penchant for Impres-
sionism but have rapidly, albeit selectively, expanded into Old
Masters as well as contemporary art, with a resulting price rise all
round.

The Japanese have been accused of buying up names rather than
pictures, but the same claim was levelled at the Americans when
they entered the market at the turn of the century. The Old Master

[68]

Establishing the provenance of a painting in the library
at Colnaghi, 14 Old Bond Street, London W1. Does the style
of the Old Master dealer disguise the fact that a commercial
art gallery is no more than a retail outlet?

Bernard Berenson, the celebrated American
art historian and connoisseur of Italian
Renaissance painting. What is the role
of the scholar in the art market?

market expanded dramatically at the end of the nineteenth century
when the American economy boomed and a handful of industrial
magnates began to build up their art collections. As the examples of
Holland in the seventeenth century and Japan today show, art seems
to flow towards surplus money. The quantity and quality of the Old
Masters that Joseph Duveen, the dealer who, backed up by the

Sir Joseph Duveen (left), the British art dealer with whom Berenson was associated for many years, and his millionaire client Andrew Mellon whose collection Duveen helped to form.

scholarship of Bernard Berenson, sold for vast sums to American millionaires, helped to establish a fashion for collecting that put the new clientele on a par with the Medici.

As the art treasures of Europe poured across the Atlantic, so the demand rapidly began to eat into what had hitherto seemed to be an endless supply, and prices began their upward spiral. No longer could a Renaissance painting be bought for less than a third of a painting by Lord Leighton; and the National Gallery in London must have been thankful that it had bought Piero della Francesca's *Nativity* in 1874 when it cost less than £2500 (£67,500 at today's prices). The irony of the situation now is that it is America's turn to be at the selling rather than the buying end of the market.

As Duveen relied on the reputation and expertise of Berenson to authenticate the value of what he was selling and to place the paintings in their art-historical context in order to hook his inexperienced American buyers, so today's Old Master dealer relies on the power of a painting's provenance to woo his clients. In this sector of the art market, however closely the dealer fosters a relationship with his client, his heritage-steeped ambience is ultimately dependent on establishing a *bona fide* provenance. To establish provenance is important on two fronts. First, in a field where works are several hundred years old and often produced in large studios, the clients need to be satisfied that the artwork under consideration is what the dealer says it is. Second, the dealer is selling tradition and membership of an old and honourable fraternity which is defined by the previous owners of a work.

Provenance is rarely a problem for dealers in contemporary art: the origin of their merchandise is seldom in doubt. What is more

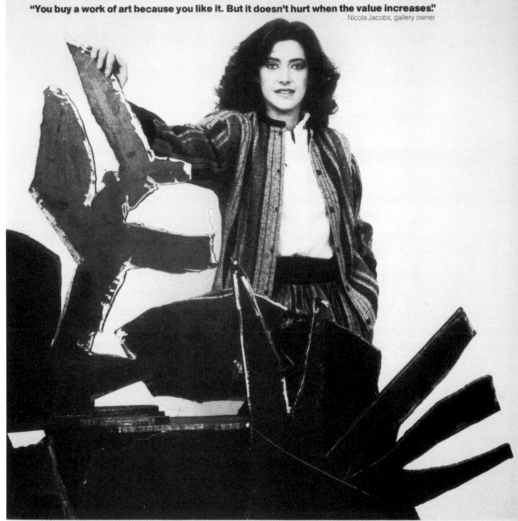

"You buy a work of art because you like it. But it doesn't hurt when the value increases."

Nicola Jacobs, gallery owner.

The people who bought Colin Smith's first paintings have got themselves a bonus. Then, he was selling for about £300. Now his prices are about £2000.

That's part of the joy of buying a new artist's work. You get them for a reasonable price and hope they take off. Most of mine have. Not all, but most.

At the moment, I represent fifteen artists. And I give them exhibitions because I expect them to make a name for themselves. Which is good for them, me and you.

This steel sculpture by Jeff Lowe is in my current exhibition which runs from now until January 29. It's a Group Show and you'll be able to see paintings, sculpture, and works on puper by many of the gallery artists.

Have you considered buying an original painting? It says a lot more about you than a new car ever will. Perhaps you should come to one of my priviate views. All you have to do is telephone me at 01-437 3868 and ask for an invitation. We'd love you to come, see the pictures, meet new people and talk to

the artists involved. After all, you never get to meet the designer in a car showroom.

We're looking forward to meeting you.

Nicola Jacobs Gallery

9 Cork Street, London, W1 01-437 3868.

Works by	Jeff Lowe
John Carter	John McLean
Shelagh Cluett	Mali Morris
Jennifer Durrant	Paul Rosenbloom
Simon Edmondson	Colin Smith
Jon Groom	Derek Southall
Ken Kiff	Anthony Whishaw
Kim Lim	Gary Wragg

Opposite: Advertisement for contemporary
art dealer Nicola Jacobs' gallery in
Harpers & Queen (1984)

debatable is its position in art history. Will today's novelties become
the museum art of tomorrow? If an artist is fashionable, does that put
in doubt the work's lasting value? The contemporary art dealer has
learnt to benefit by both utilizing and assuaging these concerns.
Like their Old Master colleagues, contemporary art dealers sell
more than just artworks. The contemporary art world is run like an
exotic club, organized around fashion, glamour and novelty as well
as exclusivity and élitism. Those who gain entry, it implies, are not
just clients but also cognoscenti. Exhibition openings at major con-
temporary art galleries are often dominated not by serious clients
(who have seen the work at a pre-preview), but by large crowds of
young, fashion-hungry party-goers. It is no coincidence that many of
America's leading artists, including Francesco Clemente, Julian
Schnabel and, inevitably, Andy Warhol, have shown their work in
nightclubs. Appearances are all-important, trends are religiously
observed and a keen sense of competition encouraged. This process
is stimulated by an enthusiastic media who fuel the image of the
artist as a celebrity and the dealer as an arbiter of up-to-the-minute
style and taste.

This image of contemporary art dealers as risk-taking purveyors
of the outlandish and exotic may seem comic in the face of soaring
profits (in 1987 Leslie Waddington's galleries reported a profit of
£3 million on a turnover of £18 million) and the involvement of
business corporations and national art institutions in large-scale
purchases of avant-garde art. But the image has a pedigree. The first
dealers to specialize in the promotion as well as the sale of con-
temporary art were marginalized figures in the eyes of the art estab-
lishment. As the gulf widened in the second half of the nineteenth

*❛The new rich are not really the same as the Medici,
they don't have the same kind of territorial power
or direct patronage, there are far too many of
them, their money is much more mobile and restless,
and they are constantly looking for new
ways of attracting attention.❜*

Anthony Sampson

century between the official art of the academies and the increasing
number of artists who did not want to conform, there evolved a new
species of art dealer who posed a challenge to the academy's
monopoly of patronage. These entrepreneurial figures who were not
constrained by the restrictions of the academy but also did not enjoy
its security had the precarious freedom of finding new markets for
artists working outside the establishment.

It was not long before the individual dealer rather than the Salon
became the place to find serious contemporary art; and the con-
stantly shifting power structure of the art market continues with
the auction houses jockeying for supremacy with the dealers today.
The contemporary dealer system scored its first decisive coup in
1870s' France by introducing the early Impressionists to the new
wealthy middle class and launching not just a new art movement but
a new market for such art. Dealer Paul Durand-Ruel supported and
exhibited Monet, Renoir, Sisley, Pissarro, Manet and Degas and by
a tireless championing of their cause, acted as a conduit between the
artists and a potential source of middle-class buyers who were out-
side the aristocratic system of patronage. In the late nineteenth cen-
tury the dealers were committed to an art which was genuinely
avant-garde; their present-day counterparts may be as seriously
dedicated to the experimental in art – but that art often now has the
status of orthodoxy.

Durand-Ruel relied on a few key critics such as Théodore Duret
and Georges Rivière (who edited the journal *L'Impressionniste*) to
legitimize his unknown artists for their potential purchasers. And
there have been other examples. Where would the Cubists have
been without the poet-critic Guillaume Apollinaire who introduced

Sol Lewitt installation, Lisson Gallery, London,
July 1989. What do you get when you purchase
art from a contemporary art dealer?

Jenny Holzer, *Money Creates Taste*
(1986), illuminated billboard,
Caesar's Palace, Las Vegas

Cubism to the public with his book *Les Peintres cubistes* in 1913, or
Jackson Pollock without Clement Greenberg who as art critic for
The Nation magazine was the earliest champion of Abstract Expres-
sionism? The critic-dealer axis also accelerated the decline of the
academies as art centres and assisted in the creation of a powerful
new clientele which continues to dominate today's contemporary

art transactions. It is claimed that the force of the present art market drowns any critical appraisal, but the judgement of critics continues to have some influence on authenticating new work and so increasing its value. Just as scholarship is crucial to the sales of an Old Master dealer, so the support of prominent critics is eagerly sought by contemporary galleries.

To stay on top, today's contemporary art dealers have to devise ways in which to maintain a prominent profile in an environment that is not only obsessed with constant change, but where there are more commercial galleries than ever before. As contemporary dealers multiplied throughout the 1980s, traditional national rivalry was eroded with associations of galleries often selling the same artist in London, New York, Düsseldorf, Paris and Milan.

To recognize, then, the differences between past and present in the art market is clearly important – and there is no doubt that the global market is new and will shift our sense of values. To identify such differences is to see something other than a money-lusting present and an art-loving past. However, to focus exclusively on money in the art market is misleading, for what the market sells is not merely a tradable commodity but a priceless way of life. What other market can offer its clients that?

The Power and
the Glory

I s art collecting just a byword for power? When the Romans expanded their empire they competed amongst themselves for the best booty to fill their villas. The Medici accumulated art to embellish their dynasty; now that Japanese businessmen are dominating world markets, they are beginning to bear off the treasures of Europe and the USA to the boardrooms and museums of the East. This is not necessarily to impugn the intentions of particular collectors. It doesn't matter whether art is amassed for propaganda, prestige or pure pleasure, the impact rather than the intention of the art collector is what counts. When a collector buys a work of art there are wide repercussions. Art collectors have a direct bearing on the market value of art, they influence the way that art is exhibited, the way that art is perceived and even what kind of art is produced. Art collectors help to make art history, while art history canonizes art collectors.

In the current world of art collecting there are two noticeable developments. Corporations have discovered the power of art and have entered the company of collectors in significant ways. Banks, insurance companies and department stores increasingly look more like art galleries as their art collections are expertly displayed, catalogued and guarded by curators. And no longer is this art restricted to the safe territory of Old Masters. Contemporary art is the focus of many of today's collections and, as prices soar, so can the reputations of artists, alive and dead. The second change is that the hundred-year supremacy of American collectors is being eroded by the Japanese who have emerged over the last decade as voracious collectors of Western art.

Public attention first focused on the Japanese as large-scale art

> *❝To demand that only the wholly virtuous and refined be allowed to buy paintings would be like screening members of a theatre audience for previous convictions.❞*
>
> Alison Lurie, in her novel *The Truth about Lorin Jones*

Giorgio Vasari, *Duke Cosimo de'Medici and his Artists* (after 1550)

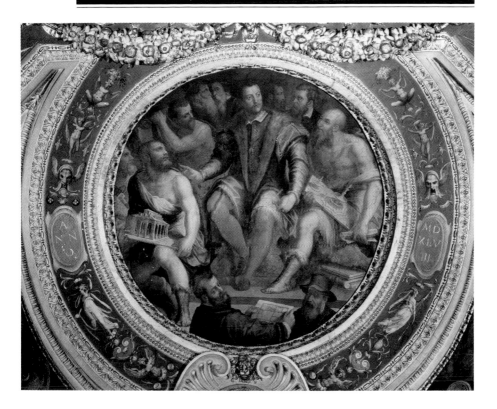

collectors in March 1987 when the Chairman of the Yasuda Fire and Marine Insurance Company bought Van Gogh's *Sunflowers* at Christie's for £24.75 million. This landmark sale heralded both the beginning of the auction house boom and the conspicuous emergence of the Japanese corporate collector, and the two have continued to be bracketed together. In fact, Japanese collectors have been present in the art market since the beginning of this century, but

*6From the moment I saw this painting I didn't
regard it as an investment . . . it was more a matter
of wanting to own something beautiful . . . it left me
with an overwhelming feeling of courage and
passion, I was amazed by its power and brightness.9*
Mr Yasuo Goto, Chairman, Yasuda Fire and Marine Insurance Company

their purchasing began to gather momentum from the early 1980s,
at the same time that a Japanese presence became apparent in every
other market across the world. By 1986 a trend towards expensive
single purchases, both by Japanese individuals and by corporations,
had become apparent (in that year alone over 100 items worth in
excess of £500,000 each had entered the country); in 1987 art
imports into Japan had more than doubled, from £230 million to
£576 million.

The sudden interest in Western art amongst the newly rich
Japanese is linked to economic as well as cultural changes. In Sep-
tember 1985 the finance ministers and central banks of the USA,
Britain, West Germany, France and Japan reached an agreement to
let the dollar find its natural level. The result was a doubling in the
value of the yen against the dollar. Japanese companies responded
by converting their dollar earnings into yen and ploughing
quantities of cash into the stock market, then into real estate and
finally into art objects. Those who owned shares or property also
found themselves immensely wealthy. The precise coincidence of
the 1987 peaking of the Tokyo property market and that year's
increased art purchases illustrates the moving over of money from
property to art. As Japan's economy continues to expand, so does
the art expenditure of its collectors. Many of these are immediately
installed in expensive storage rooms by the Sumida River on
Tokyo's East Side where their surrounding air and humidity is care-
fully regulated, but where they are rarely seen by their owners who
have bought them for investment rather than display. Van Gogh's
Sunflowers, however, is on public view at the headquarters of the
Yasuda and can be seen for an admission fee of 500 yen (about £2).

Left: Cartoon in *The New Yorker*, 17 November 1962

Below: Mr Yasuo Goto, Chairman of Yasuda Fire and Marine Insurance Company, with Van Gogh's *Sunflowers* which he bought on behalf of the company for £24.75 million in March 1987.

❛There was money in the air, ever so much money . . . and the money was to be all for the most exquisite things – for all the most exquisite things except creation . . . the Museum, in short, was going to be great.❜

Henry James, *The American Scene*, 1907

But perhaps it is the protagonists rather than the developments that are new. The flowering of the arts in Tuscany in the late fourteenth and early fifteenth centuries coincided with the period when Tuscan bankers became the chief financiers of Europe. And in late nineteenth-century America, when there was an abundance of capital in the hands of successful businessmen, the wealthiest and most active buyers in the picture market were American. It was at this time that industrial magnates such as Henry Clay Frick and Andrew W. Mellon, the railroad baron William H. Vanderbilt and the financier John Pierpont Morgan, built up their art collections.

The consequences were twofold. Morgan, for instance, was criticized for driving up the prices of everything from Fragonard panels to Byzantine ivories in the same way that the Japanese are now accused of raising the price of Impressionist and Post-Impressionist art. Secondly, America's new aristocracy used the culture of old Europe not only to acquire more wealth, but also to buy themselves a tradition that they otherwise did not have, and to obscure the source of their wealth.

But the benefits of the collector/art relationship do not flow simply in one direction. Being in a famous collection gives artworks a special aura – and can even protect fakes and misattributions. Cornelius Vanderbilt won his acceptance on to the Board of Trustees of New York's Metropolitan Museum by his bequest of nearly 700 Old Master drawings which were quickly proved to be works not by Michelangelo, Raphael, Leonardo, Titian and Rembrandt but copies and school studies. But such was the standing of their donor that the Vanderbilt gift hung prominently in the Metropolitan for many years and helped to create a new interest in artists' drawings.

J. Pierpont Morgan (seated, centre), in Egypt in 1912 to inspect his sponsored excavations which would yield more art for his great collection, a significant part of which is now in the Metropolitan Museum of Art, as well as in the Pierpont Morgan Library, New York.

It is hard not to look at a work of art in a particular way when we know that it has been selected by a well-known individual. When a proportion of Pierpont Morgan's collection was sold off after his death (he had turned out to be not as rich as everyone thought), collectors competed to pay inflated prices for Morgan pieces on the strength of his name alone. They wanted to buy into the myth that surrounded the man. And certain works are now better known by the name of their most famous collector or patron than by the artist – the Elgin Marbles, for example, or Velázquez's *The Toilet of Venus*, which acquired the new name *The Rokeby Venus* when it was bought by John Morritt of Rokeby Park in Yorkshire in 1814.

Auction houses are aware of the aura that surrounds particular individuals and they increasingly market the estates of well-known figures as 'single owner' sales, emphasizing the particular characteristics of the collector as much as the work. Today, the owner doesn't have to be dead: the image of Alain Delon was on sale alongside his Bugatti bronzes at Sotheby's in April 1990. When Timothy Clifford, the Director of the National Gallery of Scotland, sold his collection of Old Master drawings in July 1989, Sotheby's used his academic reputation to enhance the sale.

No one was more successful at gaining the pedigree that accompanies connoisseurship than John Pierpont Morgan. Although he only began to build up his vast collection of paintings, porcelain and every manner of *objet d'art* in his sixties, Pierpont Morgan's reputation was quickly transformed from that of a ruthless and overbearing plutocrat to a revered public figure whose spectacular coups on the art market were widely publicized and applauded. He purchased entire collections (in the same way that he had taken over

*❝Collecting art has become the substitute for
a big car with fins in the United States – and
I think that's probably a plus.❞*

Asher Edelman

Opposite: Titian, *Standing portrait of Emperor Charles V* (1532),
the first of his portraits of the Emperor.

bankrupt railways), bequeathed works to museums, and during what
is still remembered as 'The Morgan Era', as Chairman of the Trus-
tees of New York's Metropolitan Museum, he surrounded himself
with a formidable line-up of fellow millionaires. When he died in
1913 no other event that year was given so much space in the
world's press. The Pierpont Morgan Collection was regarded as the
greatest collection of modern times and it continues to make up a
substantial part of the Metropolitan's contents.

But there are more recent figures who have bought themselves a
history as they have bought art – such as Baron Heinrich Thyssen-
Bornemisza. The Thyssen Collection of Old Masters is acknow-
ledged to be one of the greatest private collections in the world,
equalled only by that of the Queen of Britain; while his collection of
twentieth-century art from Germany, America and Britain numbers
over 900 works and continues to expand. Thyssen inherited the
backbone of the collection from his father, and his conduct often
echoes that of the great European dynasties of previous centuries.
He lives amongst much of his collection and has a purpose-built
picture gallery at the family home, Villa Favorita, on Lake Lugano.
Just as Charles V chose Titian to represent him and the image of
Charles I was created by Anthony Van Dyck, so Baron Thyssen has
been painted by Lucian Freud.

Yet the Thyssen Collection is not as venerable as it appears. It is
entirely a product of the twentieth century and is based on an indus-
trial fortune that originated from an iron and steel works on the
Rhine established by the present Baron's grandfather. The title and
the collection came from the baron's banker father who married
the daughter of Baron Bornemisza, an impoverished Hungarian

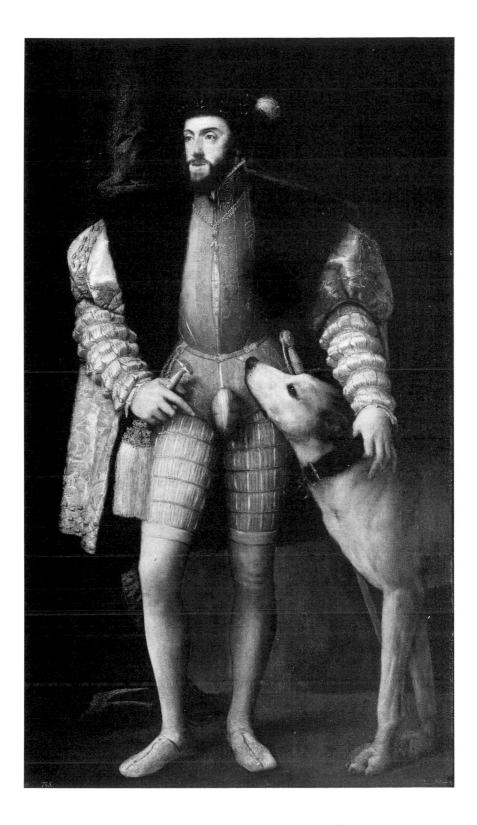

*❝I do not even see many of my most famous pictures.
Maybe two or three times a year. Yet they
give me great great pleasure . . . But to possess
for myself, no. The joy of this comes from knowing
that a new acquisition makes this a better
collection . . . more complete.❞*

Baron Thyssen-Bornemisza

Lucian Freud's portrait of Baron Thyssen, *Man in a Chair* (1983–5)

6Politically, Utz was neutral. . . . He detested
violence, yet welcomed the cataclysms that flung
fresh works of art onto the market. Wars, pogroms
and revolutions, he used to say, offer excellent
opportunities for the collector.9

Bruce Chatwin, in his novel *Utz*

aristocrat, and subsequently based himself in Hungary until the Communists took power in 1919. It was the first Baron Thyssen-Bornemisza who avidly collected Old Masters throughout the 1920s and 1930s and who built the picture gallery at Villa Favorita. It was not until the death of his father in 1947 that the present Baron began to take an interest in collecting and to buy back the pictures that his father had left to other members of the family. The first picture that he actually bought, as opposed to bought back, was the Renaissance artist Francesco del Cossa's *Portrait of a Man* in 1954.

Since then Baron Thyssen has expanded his collection and its influence. Portions of the Thyssen Collection have toured to prestigious venues throughout the world: Britain's Royal Academy showed 'Modern Masters from the Thyssen Collection' in 1984, and 'Old Master Paintings from the Thyssen-Bornemisza Collection' in 1988. Some of Thyssen's 'masterpieces' have also been shown in New York's Metropolitan Museum and Raisa Gorbachev was a special admirer of the collection when it toured the Soviet Union in the mid-1980s.

But art collecting doesn't only give a collector from the business or industrial world a pedigree. It is also – and the dividing line is thin – a splendid weapon in his commercial armoury. In 1988 Baron Thyssen let it be known that he was seeking a permanent home for his collection after his death. It was a considerable fillip to his reputation when a number of countries (including Britain, whose offer of £100 million and a special gallery was personally backed by Margaret Thatcher and the Prince of Wales) vigorously lobbied to win this prize. Thyssen kept everyone on tenterhooks for several months, before finally deciding to send the collection to Spain,

which already had the bulk of the collection on a ten-year loan in the refurbished Villahermosa Palace in Madrid. Apart from the fact that the Baron's fifth wife is Spanish, it is also no secret that the Thyssen family has business dealings with RENFE, the Spanish national railways.

Yet no one should become nostalgic for the good old days before businessmen used art to promote themselves. The use of an art collection as a diplomatic tool (and isn't that how Thyssen uses his?) has a long history. In 1623, when still a prince, the future Charles I visited the court of Philip IV in Spain and flatteringly asked for a portrait of Charles V, the most glorious of the Hapsburgs. He was presented with a full-length portrait of the emperor by Titian and, as a further gesture of friendship (the two countries had only recently been at war), the prince also received from the Spanish court Titian's *Woman in a Fur* and the *Venus del Pardo*. That this was the use of art for diplomatic purposes – and under this term sheltered issues of trade – can be seen when Charles I's great art collection was sold off after his execution (Oliver Cromwell kept Mantegna's *Triumph of Julius Caesar* for himself). Even though the sale was a consequence of regicide, the crowned heads of Europe competed for the spoils. The Spanish ambassador managed to retrieve one of the Titians – but it was not simply a love of beautiful objects which motivated this kingly act of treachery. It was an awareness of the usefulness of art in the diplomatic game and that art was a symbol of power. Spain's reputation would have suffered if all the Titians had gone to another nation.

The new breed of Japanese collector uses art in different but no less effective ways for his international purposes. Financier

[88]

*6My appreciation and enjoyment of art are aesthetic
rather than intellectual. I am not really concerned
with what the artist means; it is not an intellectual
operation – it is what I feel. 9*

Nelson A. Rockefeller

Yasumichi Morishita attracts attention to his Aichi Corporation by controlling the Aska Gallery in Tokyo which reputedly owns over twenty Monets alone. In 1989 Aska spent $25 million at the four-day auction of Modern and Impressionist paintings belonging to late Campbell's Soup heir John T. Dorrance Jnr, as well as just under £20 million in the salerooms of Europe, picking up one Picasso and several minor Impressionists. Aska's high profile enhances Morishita's other holdings, which include a finance company and several golf-courses.

Similarly the Seibu Group houses three art galleries in its giant Tokyo department store and a large museum for its permanent collection just outside the city; the Fuji Sankei Communications Group runs the Hakone Open-Air Sculpture Museum and the Fuji Television Gallery, which shows contemporary Western and Japanese artists. Throughout Japan, art collections are used as an advertisement for corporate power rather than a diversion from it.

As they are in America. The art collection of Chase Manhattan Bank is the country's largest and most important corporate collection; and its thirty-year evolution from the brainchild of an individual to a collective enterprise involving more than 11,000 items located in fifty-five countries shows how the philosophy of art collecting in America has shifted from the individual to the collective.

When Chase Manhattan's President David Rockefeller decided in 1959 to start a programme of art acquisition to decorate the bank's newly-built headquarters near Wall Street he was continuing a family tradition. His politician brother Nelson A. Rockefeller was a well-known patron and collector (he funded the Michael C. Rockefeller wing in New York's Metropolitan Museum) and their

The Chase Advantage, silkscreen on acrylic (1976):
German artist Hans Haacke's reworked advertisement
for the Chase Manhattan Bank. By turning corporate
slogans and advertisements into art, Haacke draws
attention to the social and political implications of the
sponsorship of art by big business.

Give yourself The Chase Advantage

Even accountants put a money value on such intangibles as good will, and it is the conviction of Chase Manhattan's management that in terms of good will, in terms of staff morale and in terms of our corporate commitment to excellence in all fields, including the cultural, the art program has been a profitable investment.

David Rockefeller

Photo: William E. Sauro, *The New York Times*

David Rockefeller (Chairman of Chase Manhattan Bank, Vice Chairman of Museum of Modern Art) in *Art at the Chase Manhattan Bank*

The fundamental purpose, therefore, which must underlie any policy of publicity must be to induce the people to believe in the sincerity and honesty of purpose of the management of the company which is asking for their confidence.

Ivy L. Lee (public relations consultant, hired by John D. Rockefeller Jr., after «Ludlow Massacre», 1914) in *Publicity: Some of the Things It is and is not*, New York, 1926

CHASE

*6We business people who support
the arts today are like
the Medici and the other
collectors and supporters of
art in history – only better.9*

Winton M. Blount, Chairman of Blount Inc., 1984

mother Abby Aldrich Rockefeller had been one of the founders of
New York's Museum of Modern Art. But Rockefeller had to
legitimize his art expenditure to the shareholders, especially since a
limited budget and the design of the new headquarters dictated that
the art should be contemporary. In order to validate what was seen
as a precarious investment, if not an outright waste of company
money, Rockefeller involved art historians and museum directors in
its acquisition. Chase Manhattan's first Advisory Board included
Alfred H. Barr of the Museum of Modern Art, James Johnson
Sweeny of the Guggenheim Museum, Robert B. Hale of the Metro-
politan Museum of Art and Perry Rathbone of the Boston Museum
of Fine Arts. In 1967 Rockefeller encouraged other corporations to
support the arts when he established the Business Committee for
the Arts with investment banker C. Douglas Dillon, former US Sec-
retary to the Treasury, Ambassador to France and Chairman of the
Metropolitan Museum in New York. The intimacy between collec-
tors and museums, although nothing new, is currently giving cause
for concern. Corporate collections boast museum-quality art and
the issue now is what price does the museum world pay in order to
maintain the cooperation of the corporations?

 With the kudos it brings, no wonder it is now standard procedure
for major American corporations to collect art. Most American cor-
porate collections took Rockefeller's lead and started by collecting
contemporary art. Whereas Japanese corporations are only now
revising their view of contemporary art as an amusing sideline and
seeing it as a viable asset which is popular with the young market,
American business at once realized the advantage of contemporary
art as plentiful, relatively affordable and capable of yielding high

Above: Equitable
Center atrium, New
York, with a mural by
Roy Lichtenstein and,
in the centre, stone
furniture-sculpture by
Scott Burton.

Left: Jeff Koons,
Winter Bears (1988).
Art made for the
corporate collector?

returns. It is also fashionable. And access into the world of high fashion is an increasingly valuable commodity for a business as the Japanese are beginning to realize with Seibu's New York graffiti show, Frank Stella reliefs on jewellery advertisements and the employment of the British artist Bruce McLean to decorate one of Tokyo's leading nightclubs.

Art now operates for corporations as it did in previous centuries for the courts of Europe – it is part of their armoury of self-advertisement. Philip Morris adopted the slogan 'It takes Art to Make a Company Great', PepsiCo acquired a collection of large-scale outdoor sculpture for its new headquarters in Westchester, New York, and the Equitable Life Assurance Society compensated for a late entry into the field when in 1986 it spent $7½ million on works of art for its new headquarters building in midtown New York. The public street floor of the Equitable Center calls itself 'the largest corporate complex ever developed' and claims the Rockefeller Center as a role model.

But does the corporate appetite shape contemporary art as it reshapes the art world and its institutions? Until recently there was no such a thing as museum art. Are we now to see corporate art, and what will it look like? Pari Stave Choate, the curator of Equitable's collection, claims that corporations are in a position to nurture performance art, large-scale and site-specific art, and 'certain trends in art that are not made possible through a museum'. Others are less confident. Which bank is going to want contemporary versions of Goya's war art on its wall? Perhaps we are destined for a certain kind of decorative figurative or abstract art, or the most innocuous forms of Post-Modernism such as the work of Jeff Koons. After all, this

❝COSTO FIOR. 4 MILA E. MARMO. SOLO❞
(the marble alone cost 4000 florins)

Inscription on the tabernacle in the church of
SS Annunziata, Florence, commissioned by Piero de'Medici

collecting is not like that of an older generation such as the de
Menils who collect art as a personal passion, or like the Medici who
used art as a sign of personal power. It is an activity that has to satisfy
shareholders and customers.

But art collecting, whether good for art or not, if done expertly is
beneficial not just for a company's public face – it actually boosts
business. When Chase Manhattan opened a branch in New York's
Soho art district, they converted its ground-floor lobby into a white-
walled, top-lit art gallery with a changing programme of four shows a
year taken from the company collection. This hybrid gallery-bank
(the tellers' booths and offices are hidden away at the back) was a
deliberate tactic to attract new accounts from amongst the local
clientele of artists and gallery owners. And they responded: many of
the largest galleries in the area now hold accounts at Chase Manhat-
tan. The Equitable Society also makes no secret of the fact that the
art expenditure on their Equitable Center enabled the company to
charge higher rent from the building's other tenants. (Although they
paid for the construction of the Equitable Center, the Equitable
Life Assurance Society only occupy seventeen of the building's
fifty-four floors. Evidently Roy Lichtenstein, the Italian Sandro
Chia (whose murals decorate the restaurant) and Scott Burton can
help to sell real estate in the same way as Cimabue and Giotto were
employed to celebrate Christianity or Michelangelo the Medici.)

As art takes up its place as another business asset alongside real
estate, stocks and bonds, art collectors are advised as much by busi-
nessmen as academics. The established infrastructure of curators,
critics and museums which supports and is supported by collectors
has had to accommodate a financial bias in art advising. In 1980 the

❝*I buy modern pictures because it's safer. And then they'll go up in price. For instance, we did well buying Ary Scheffer's* Margaret at the Fountain. *He died soon after. The sooner they die, these fellows, the better.*❞

Isaac Pereire, art collector, quoted in the Goncourts' *Journal*

Association of Corporate Art Curators was founded. The boom in corporate collecting throughout the decade has given work to a whole new professional class of art curators who no longer find it ignoble to be employed by big business. Figures like Bernard Berenson, American collector Peggy Guggenheim's early British critic-mentor Herbert Read, or even Rockefeller's committee of museum curators are giving way to institutions like the Citibank Art Advisory Service. Founded by Citibank in 1979, this new department comprises a team of art historians and curators from different fields who provide 'a tailor-made service for individuals who want to buy art'. It caters for clients who spend, on average, over a million pounds on art a year, and its services extend from advising on price, suggesting purchases and arranging loans to organizing the framing, transport and restoration of artworks. Just as the supermarket replaces the butcher, baker and grocer, so this body of advisers can – for a fee – be dealer, banker and curator all at once.

With these priorities, the role of the art critic becomes precarious: it may now be the collector with his or her favourite galleries who sets fashionable taste. Advertising agency owner Charles Saatchi did not seek to legitimate the art that he bought from New York art dealer Mary Boone and London gallery owner Bernard Jacobson by reference to critics. When he bulk-purchased Neo-Expressionist artists in the late 70s and early 80s not only did he drive up the prices of Julian Schnabel, the New York artist David Salle and Sandro Chia, but he also helped their general standing in the art world. In a similar way, not only the financial value of those painters but also their critical reputation was damaged when several years later he sold off first his entire stock of Chia and then works by

Opposite above: Hans Haacke, *On Social Grease* (1975).
Haacke presents the petro-chemical giant Exxon's
self-advertisement in plaque form.

Opposite below: Citibank's advertisement for its
private banking and investment service.

Schnabel, Kiefer, Immendorff and others. He did much of this
through the New York dealer Larry Gagosian who has made his
name in the expanding field of 'secondary market' dealing, the
direct transferral of artworks from collector to collector. Although
Saatchi is not a collector who is as responsible as others for forming
taste, can one doubt that his heavy investment in the so-called
'School of London', which includes figurative painters such as
Frank Auerbach, Lucian Freud and Leon Kossoff, has not helped
the critical standing of painters such as Kossoff? If such a com-
mitted internationalist buys into British art then there must be
something in it, mustn't there? And, of course, Saatchi has the
gallery space to bestow public visibility on his judgements.

Saatchi is one of the new generation who have been described as
narrowing the distinction between collector and dealer. When they
buy and sell, in what capacity do they do it? An artist may feel differ-
ently if he or she is selling to a dealer rather than a collector.
Japanese collectors are especially adept at blurring the boundaries
between collecting and commerce. Fuji openly support their Tele-
vision Gallery by dealing in nineteenth- and early twentieth-century
masters; the Aska Gallery makes no secret of selling as well as
buying its paintings. Morishita has its 6.5 per cent sharehold in
Christie's while Seibu's director sits on Sotheby's advisory board
and the Seibu Group acts as Sotheby's agents in Japan and holds
preview shows of forthcoming sales – including the Warhol Collec-
tion. Seibu, the world's largest department store, contains within it
the Contemporary Art Gallery which is a purely commercial
venture, and the Seibu Art Museum on the top floor which enhances
the company's profile by blending prestigious exhibitions with

EXXON'S support of the arts serves the arts as a social lubricant.
And if business is to continue in big cities, it needs a more lubricated environment.

Robert Kingsley

The acquisition of art is itself an art.

Only one bank can give serious collectors both the professional art market advice and ready capital they require — Citibank Private Banking & Investment.

Our unique Art Advisory Service is just one example of how Citibank Private Banking & Investment can meet the complex and unusual needs of the successful entrepreneur.

In major cities around the country, our relationship managers can respond quickly and confidentially to everything from lending against illiquid assets to portfolio management to administering complicated estates and trusts.

CITIBANK
PRIVATE BANKING & INVESTMENT

Fluent in the ways of the affluent.℠

David Teniers II, *Gallery of Archduke
Leopold William* (*c.*1651–6). It is not only
contemporary corporations who have bought
art in bulk.

aggressive marketing. Its Joseph Beuys Retrospective Exhibition coincided with the launch of Beuys' commercial for the Super Nikka whisky company; for their Yves Klein Retrospective, sachets of Yves Klein's characteristic International Klein Blue powder pigment were sold in the Seibu Museum foyer; and to accompany their large New York graffiti artists' show the company issued special credit cards designed by graffiti artist Keith Haring. These avant-garde sponsorship tactics were especially effective in enhancing the company image with the high-income under-thirties market.

Corporate collections dwarf individual collectors who in their role as patrons seem in certain ways residual – although the importance and impact of the de Menil family is still visible. Dominique de Menil presides over what is probably both the largest collection of twentieth-century art in private hands, as well as the largest family of collectors. Dominique and her husband John (who died in 1973) left occupied France in 1941 and settled in Houston, Texas, the North American headquarters of her father's oil services company, Schlumberger Ltd. Schlumberger still forms the basis of the de Menil family fortune, estimated at over $400 million, which enabled John and Dominique de Menil to build up a collection of more than 10,000 objects which is now divided between Dominique de Menil's home and the Menil Collection which opened in Houston in 1987. The scope of the collection extends from antiquities and Pre-Colombian, African and Oceanic art, through Cubism and De Stijl, to some of the world's best Surrealist pieces and top examples of Minimalism and Conceptual art. Many of the twentieth-century works were made especially for the de Menils.

Andy Warhol, *Portrait of Dominique de Menil*, silk-screen print (1966)

RELATIVE VALUES

A monument to the de Menils? It cost Dia $65,000 just to purchase the crater for James Turrell's ongoing *Roden Crater* earthwork in Arizona's Painted Desert.

More than any other collectors the de Menils have brought the
time-honoured practice of commissioning as well as collecting art
into the late twentieth century. No twentieth-century collector can
compete with the patronage of Cosimo de' Medici in Florence
whose legacy included works by Masaccio, Donatello (including his
David), and Uccello as well as the hire of Brunelleschi to build the
Church of San Lorenzo and Fra Angelico to paint frescoes for the
Convent of San Marco, but the de Menils come close. American
Minimalists Donald Judd and Richard Serra are among the many
other artists to make special (and major) pieces for the de Menils;
and the most famous act of de Menil patronage which has assured
the family a Medici-like status is the Rothko Chapel in Houston,
paintings for which were commissioned from the artist Mark Rothko
in 1963.

The de Menil tradition of art patronage extends to the five chil-
dren: Christophe, Georges, Adelaide, François and Philippa are all
active collectors. Philippa has been especially influential as the
founder (with Frankfurt art dealer Heiner Friedrich) of the Dia Art
Foundation. Dia – a Greek word meaning catalyst or conduit – was
established in 1974 and from the start it laid a particular emphasis
on projects that were too vast and too expensive to receive funding
from any other source. No expense was spared. Dia offered selected
artists long-term unlimited financial support for projects that took
years to plan and execute and in the first ten years of its existence
spent $30 million on art and artists. Dia projects include Walter de
Maria's *Lightning Field* in New Mexico and his *Earth Room* in New
York City and James Turrell's *Roden Crater* earthwork which
involved buying an entire volcano crater in the Arizona desert.

Undoubtedly patronage on this scale enhances the de Menils'
international prestige. The Rothko Chapel is an asset, just as the
Church of San Lorenzo and the Convent of San Marco were for the
Medici; and we only have to look at Pope Leo X or Louis XIV for
grandiose precedents for Dia's patronage. Many of the de Menils'
scholarly projects, such as their publication of a catalogue raisonné
of René Magritte, increase the market value of their holdings (they
have many of Magritte's greatest paintings), and what seemed at the
time to be daring commissions have usually turned out to be sound
investments. But unlike Heinrich Thyssen or for that matter
Cosimo de' Medici, the de Menils do not court publicity for them-
selves or their business interests. Schlumberger Ltd is kept separate
from the de Menils' art activities and for many years few people in
New York even realized who was backing the Dia Art Foundation.

Whatever their different characteristics, the motives of art collec-
tors have always extended beyond the fiscal. There are always other
commodities which are less precarious and can guarantee higher
returns on a multi-million-dollar investment, and there always have
been. But there are few investments that can offer the rich the
return that art does: secular immortality.

Art of the State

oney is not the only feature of the art world that has global ambitions. At any given time, in New York, Tokyo, Cologne, Paris or London, work from many nations is on show. It has become common practice for leading contemporary artists to have exhibitions in more than one country at the same time. During May–June 1990, for example, British artists Gilbert and George had solo exhibitions in New York and Moscow as well as work in mixed shows in Glasgow, Turin and Bordeaux; in the same period the German artist Georg Baselitz had simultaneous one-man shows in London, Zürich and Madrid. Even if we accept that the global art scene actually consists of a network of cosmopolitan cities, it is nevertheless true that art increasingly recognizes few boundaries.

It is therefore something of a paradox that there has been a resurgence of art celebrated, or at least packaged, in national terms. Consider some of the titles of important shows which have recently taken place in Britain. There have been the Royal Academy's blockbuster exhibitions of German, British and Italian art of the twentieth century, the Barbican's '100 Years of Russian Art' and 'La France: Images of Woman and Ideas of Nation' which was a response by Britain to the bicentennial of the French Revolution. In all these exhibitions art was put within the national frame and was seen to be the bearer of a national spirit.

This is a very different situation to the early part of the century when the cosmopolitanism of artists was *de rigueur*. For example, Dadaist, Surrealist and Minimalist artists as well as many geometrical abstract groupings (from the Holland-based *De Stijl* to Britain's Seven and Five Society or France's *Abstraction-Création*) all saw

Eugène Delacroix's *Liberty leading the People* (1830) is still an icon of the French nation.

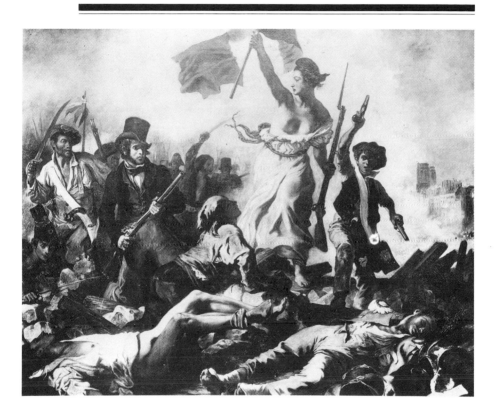

themselves as essentially international, linked by aesthetic and conceptual issues which had a 'universal' reading. Even when the Russian Constructivists specifically linked the production of abstract art to the events of the Soviet revolution, they did not see their form of geometrical abstraction as uniquely Soviet, any more than they considered Communism to be suitable only for their nation.

Many now see this kind of artistic cosmopolitanism as redundant,

'The Rescue of Art', cartoon by Ad Reinhardt
in *Newsweek*, 12 August 1946

one of the last vestiges of an optimistic Modernist programme;
national identity is what matters in critical and financial terms.
Countries have become aware of the vast tourist revenues to be
gained from promoting their artistic heritage. In 1990, the Dutch
energetically celebrated the centenary of Van Gogh's death, raising
their profile among the tourist class (which stretched to Japan where

the opening of the celebrations was screened live on television). In Britain it has been suggested that the Tate Gallery should become a contemporary art museum of the first rank not only to reflect past achievements but also, and more importantly, so that London can compete with other major cities as an art tourist attraction.

But the 'rediscovery' of national art is more than a simple matter of raising revenue. In historical terms, it can also be related to the gradual collapse of the Cold War, which has been taking place not just in the last year or two but over a much longer period. This is clearly an issue worthy of a book in its own right, but here it is enough to note its effects, direct and indirect, in the art world. With the relaxation of the Cold War has come a questioning of orthodoxies including the one which assumed that the USA, and particularly New York, were the centre of important cultural life. Nations willing formerly to concede their reliance on the US for innovation have rebelled.

During the late 1970s, for example, West Germany's museums, which had tended to give prominence to other European and North American twentieth-century painting, began to displace it with German work, showing that they were beginning to feel more culturally self-confident. Following the opening of the Berlin Wall it will be interesting to see if Germany will begin to enjoy in the cultural field the profile it enjoys in the economic.

A similar recovery of self-confidence can be seen in Britain where the rehanging of the Tate in 1990 was the occasion when it was formally recognized that British art had emerged from the shadow of US art, and was allowed, via the critically acclaimed 'School of London', to be the equal of earlier schools such as those

❛The establishment of a National Gallery is a formal recognition on the part of the Government . . . of the powerful influence which the fine arts were intended by Providence to exercise on mankind. . . . The selection, therefore, of works of art is a question of national importance.❜

Letter to *The Times*, 19 November 1846

of Paris and New York. In this context the publication of a magazine like the late Peter Fuller's *Modern Painters*, established in spring 1988, which set its face against 'art world internationalism' in favour of a 'provincial art', as Fuller tended to describe British art, looks to be less an oddity and more a part of a larger movement to promote British art. But there are problems with such a position. Attempts to categorize art according to national definitions tend to rely at least as much on exclusion as inclusion. What isn't considered, say, as English art, often becomes more important than what is, and a selection based on identifying what is 'alien' can come perilously close to racism, as in the condemnation earlier this century of the work of the American/Jewish sculptor Jacob Epstein, who became a British citizen in 1907, for being 'un-English'.

There is also the problem that all histories, including national ones, are selections from the past – and are often employed to serve present ends. This was very clear in the Royal Academy's 1985 blockbuster exhibition 'German Art of the Twentieth Century' organized in conjunction with the Staatsgalerie, Stuttgart, which excluded all examples of the German Neo-classical art promoted by the Nazis. By doing so, it placed contemporary painters such as Georg Baselitz and Anselm Kiefer in an uninterrupted historical continuum which followed directly from the Expressionist art of Max Beckmann, Ernst Ludwig Kirchner and Hans Richter. This desire to legitimate Germany's contemporary Neo-Expressionist artists as the sole heirs to the German cultural heritage not only resulted in an edited version of German history, but also disguised other factors which did not suit a nationalist thesis, such as the equally important role in postwar German art of American Abstract

*6All I know is that, in spite of those
who hold it against me, it's an honour to
represent my country. 9*

Antoni Tàpies, Catalan artist

Expressionism. Likewise the notion of a national English tradition
in painting removes such artists as Graham Sutherland and John
Piper from a wider social and political context. Instead it views their
work as epitomizing and perpetuating an essential 'Englishness'
that supposedly makes them the successors to Samuel Palmer and
John Constable, via the Pre-Raphaelites. Yet Piper, for example,
was a keen and cosmopolitan advocate of geometrical abstraction
throughout the 1930s, while at the same time painting the romantic
landscapes for which he is best known; Sutherland lived in France
for the last twenty years of his life and was especially influenced by
the Surrealists.

Clearly it is dangerously misleading to vacuum-pack art either of
the past or of the present into neat national parcels, yet it is done for
a very obvious reason. By celebrating its art, a country asserts its
identity and status both to those within as well as those outside its
borders. The Yemen Arab Republic recently tried to put itself on
the world art map by mounting 'Yemen', a touring exhibition of cul-
tural artefacts which was shown in Germany and the Netherlands.
Catalonia, a nation within the nation-state of Spain, is trying to
reassert its cultural autonomy, partly through a series of exhibitions
identifying a particular Catalonian Modernism (including the work
of the great architect of Barcelona, Antoni Gaudí). The USSR
dramatizes its new post-*glasnost* identity by reclaiming its hitherto
repressed Modernist past in the form of touring exhibitions such as
the Kasimir Malevich Retrospective which went from Moscow and
Leningrad to the Stedelijk Museum in Amsterdam in spring 1989
and the 'Rodchenko Family Workshop' which included many works
by Alexander Rodchenko never before seen outside the USSR

and went to the Serpentine Gallery, London, and the Glasgow Art Museum in 1989–90.

Spain is perhaps the clearest contemporary example of a nation that has unashamedly used art to raise its cultural status and profile both inside and outside the country. Trying to slough off the Franco inheritance which had condemned it to insularity and ensured that many of its major artists left the country and would not return (Picasso refused to allow his famous painting *Guernica*, commemorating the destruction of the ancient Basque capital by Franco's German allies during the Spanish Civil War, to be shown in Spain during Franco's dictatorship – it is now back in the Prado, Madrid), the Spanish government has been very active in promoting art. For instance, it wooed Baron Thyssen to loan much of his great collection to Spain, it has supported and financially sustained Spanish contemporary art in order to put it on the international art map, and has funded a major museum building programme which ensures that more of the important international exhibitions now pass through Spain. There has been a less direct but no less effective promotion of Spain through its art of the past. The recent exhibition of Velázquez began at the Metropolitan Museum in New York (and followed another Spanish show there, 'Goya and the Spirit of Enlightenment'), then went to the Prado where crowds queued all day to get into the show. The Spanish people, as well as the rest of the world, were reminded that this nation had a heritage that could stand comparison with that of any country.

National art clearly has no one simple meaning. It can range from the conviction that, say, the Spanishness of Spanish art can be identified in an artist such as Velázquez, through the cultural role of

⁶The centre of Western culture is no longer in Europe. It is in America. It is we who are the arbiters of its future and its immense responsibilities are ours. The future of the arts is in America.⁹

John Peale Bishop, 1941

art in helping to shape national identity, to the promotion of art as an aspect of domestic or, more often, foreign policy. But what all these interpretations and processes show is that national art is not something clearly definable, a particular national characteristic that can be pointed to in a particular work, but is something forged in particular circumstances.

This is nowhere more clear than in the case of postwar American painting – the Abstract Expressionism of painters such as Jackson Pollock and Mark Rothko which had come to be seen as the legitimate heir to European Modernism. How did the unlikely art of Abstract Expressionism come to represent America's contribution to the world of art, and why was that contribution considered quintessentially American? And what was the relationship between the success such painting enjoyed and the fact that the USA, and particularly New York, took over from Paris the title of the art world capital after 1945?

As with so many other aspects of life, the Second World War was a watershed for art. The Nazi occupation of Paris helped to break that city's claim to be the home of modern art since a large number of artists of all kinds had fled to America to escape Fascism. In that sense America had brought Europe literally to its shores. But it wasn't enough to ensure that America succeeded to the cultural throne. There was a real recognition among the US power élite that the nation must develop a cultural identity of its own. As the media personality Clifton Fadiman put it in a panel discussion broadcast in 1940: 'We are through as a pioneer nation; we are now ready to develop as a civilization.'

The success of the USA in the Cold War may be measured by

6American art today is aesthetically bankrupt.9

Peter Fuller, *Modern Painters*, 1988

the fact that within a decade of the end of the Second World War, America enjoyed a cultural reputation that fitted its new world power status. This was no happy coincidence but rather the result of a concerted government policy which had begun during the war with the 'Buy American Art' weeks of 1940 and 1941, which were intended to generate popular interest in American art within the USA, and continued after the war through the CIA's undercover aid to a host of cultural programmes and intellectual endeavours throughout Europe from the liberal socialist *Encounter* magazine in Britain to the Voice of America radio station which broadcast to Eastern and Western Europe.

The available evidence does not prove that the US government directly promoted the Abstract Expressionists, but there is no doubt that the Museum of Modern Art in New York did, not least in the 1950s through its vigorous international programme which arranged touring exhibitions of Abstract Expressionism around the world, including to London, Paris, São Paulo and Tokyo. There is clear evidence that MOMA trustees and directors were part of the business and political network which shaped postwar US foreign policy.

Since its foundation in 1929, the museum had always been dominated by the Rockefeller family, one of the key dynasties in US business and political life. Abby Aldrich Rockefeller had persuaded her husband to donate $5 million and the land on which the museum was built. Throughout the 1940s and 50s the museum was effectively controlled by her son, the politician Nelson Rockefeller. It was he who financed MOMA's international programme, which included the purchase in 1954 of the American pavilion at the

Jasper Johns, *Three Flags*, encaustic on canvas
(1958). A painting which tried to empty of meaning
the symbol of US pride.

Venice Biennale, and who appointed Porter A. McCray to direct
MOMA's international programmes, first as director of circulating
exhibitions and then as head of the museum's International Council
during some of the most crucial years of the Cold War.

With the Soviet Union committed to a crude Socialist Realism in
art that determined subject-matter, idiom and stance and that ruth-
lessly suppressed other kinds of art, American Abstract Expression-
ism seemed to show that the USA embodied all that the USSR
denied: experiment, freedom and individual expression. (Not the
least of the ironies of this history is that a number of the major paint-
ers were former Trotskyists who had worked on the radical public
art projects of the 1930s generated by the Works Progress Adminis-

tration (WPA), as part of Roosevelt's 'New Deal', which had aimed
to stimulate national recovery from the Depression.) In this sense
Abstract Expressionism was simply the latest form that the avant-
garde took – and America the place that nurtured and guaranteed it.
By 1948 enough interest in Abstract Expressionism had been gen-
erated for the popular *Life* magazine to organize and report on a
panel discussion of 'Fifteen Distinguished Critics and Connois-
seurs' – which included the critic Clement Greenberg, Abstract
Expressionism's earliest and most vociferous champion – who
undertook 'to Clarify the Strange Art of Today'. The following year
the magazine ran a long, richly illustrated feature entitled: 'Jackson
Pollock: is he the greatest living painter in the United States?'. Even
before MOMA took over the American Pavilion, America's 1950
Biennale representatives included some of Abstract Expression-
ism's leading exponents: Jackson Pollock, Willem de Kooning and,
posthumously, Arshile Gorky. The international response to these
artists' works secured their position at the head of the avant-garde:
'Compared to Pollock, Picasso, poor Pablo Picasso . . . becomes a
quiet conformist, a painter of the past,' declared the Italian critic
Bruno Alfieri. What had once been European was now American;
what had once taken place in Europe now took place in New York.

Of course this version of history has not gone unchallenged.
France for one has recently been striking back via an ambitious
museum building programme and a provocative choice of exhibi-
tions. The French challenge to New York's domination of postwar
art was first posed by the opening of the Centre Pompidou in Paris
in 1977 and its series of mammoth exhibitions, 'Paris-Berlin'
(1978), 'Paris-Moscow' (1979) and 'Paris-Paris 1937–57' (1981),

each backed up by a comprehensive catalogue-book. This determination to elevate the status of European, and especially French, art from the postwar years onwards was restated in the exhibition 'L'Art en Europe: Les années décisives 1945–1953', which accompanied the opening of the new Museum of Modern Art in the industrial town of St-Étienne in 1987–8. The opening of the massive Musée d'Orsay and the extensive Parc de La Villette complex, along with the conversion of the seventeenth-century Hôtel Sâlé into the Picasso Museum, have helped to establish Paris as the museum capital of Europe; while I. M. Pei's giant glass pyramid, the centrepiece of the 'Grand Louvre' renovation, has given France a symbol of cultural identity that is already being compared to the Eiffel Tower.

But there is nothing new in a nation recognizing the importance of its art – and even making it part of its diplomatic armoury. In the sixteenth century Machiavelli had observed that in order to retain power a prince need not be virtuous but only appear so, advice which seems to have been followed by the rulers of Europe as they instructed their court painters to present them as both strong individuals and potent figureheads of their nation. Elizabeth I was sufficiently aware of the power of the image to decree that all pictures of her by unskilful 'common painters' be destroyed. She would only countenance the reproduction of carefully chosen images such as the 'Ditchley' portrait. The present-day portraits of Queen Elizabeth II such as the one by Pietro Annigoni are a late descendant of those earlier portraits but do not have their significance. Now perhaps it is official photographers such as Lord Snowdon and Norman Parkinson who play the role, formerly occupied by artists, of projecting a chosen image of monarchy. But it should not be assumed

Left: I. M. Pei's pyramid in the Louvre, part of
the attempt by France to claim for itself the status
of museum centre of the world.
Below: The 'Ditchley' portrait of Elizabeth I
(c.1592) by Marcus Gheeraerts the Younger

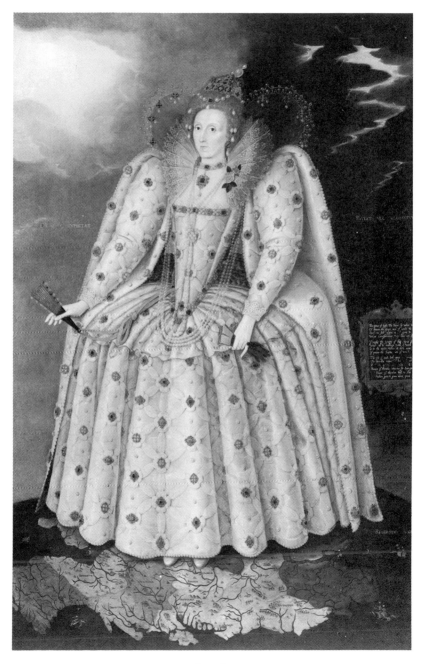

that it was only hereditary rulers who used art to strengthen their authority: as well as being the painter of the French Revolution, Jacques Louis David's post-Revolutionary paintings turned Napoleon into an icon of the nation.

Yet while it now tends to be the governments rather than individual rulers who collect and display art to embellish their power, how much change is there in the motives? Just as France is now challenging the cultural supremacy of America, so in 1665 Louis XIV invited the well-known sculptor Gianlorenzo Bernini to Paris, not just to produce great art and to design a new Palais du Louvre, but also because the Sun King was determined to humiliate Pope Alexander VII by depriving him of his favourite artist and most valuable asset. Art has often had top priority in the power games of a nation. When Charles I acquired the famous art collection of the Gonzaga Dukes of Mantua in 1627 – eight paintings for £25,000 – he regarded it as the greatest triumph of his reign (the Grand Duke of Tuscany and Marie de' Medici, the Queen Mother of France, had also been contenders) – but as a result of his purchase the military campaign to relieve La Rochelle failed through lack of funds.

Nations can establish their power not only by celebrating their own art but also by appropriating the culture of others in their art. The emergence of Orientalism in nineteenth-century French art was part and parcel of France's colonization of Algeria, which followed the French seizure of Algiers in 1830, when things Arabic (or, as they were then perceived, 'Oriental') rapidly became fashionable throughout Europe. In Orientalist painting, the colonizing power did not deny a cultural identity to the conquered land, but fixed its essential identity, often in terms of 'irrationality' and 'femi-

*❛There is a tendency to approach an alien
or semi-alien culture through its past, or at least
through received and sometimes static notions
of that past. And certainly Britain's
historical relationship with India is so potent
that it inevitably colours any attempt to look
at the present.❜*

Deanna Petherbridge, artist

ninity' against its own 'rationality' and 'masculinity'. Some of the
major works of nineteenth-century French painting, such as
Delacroix's *Women of Algiers* and *Death of Sardanapalus*, are part
of this Orientalist tradition which found in subordinated cultures
subject-matter and thus particular ways of painting unfamiliar to
metropolitan France.

Paul Gauguin's famous journey to Tahiti in 1891, and the work
that he subsequently produced on the South Sea islands until his
death there in 1903, established him in art history as the founder of
Modernist Primitivism. But this cannot be understood outside of
the relationship between France and its colonies – this time, those
of Polynesia. Tahiti had been a French colony since 1880 (this gave
Gauguin a 30 per cent reduction on his fare) and was said to be pop-
ulated by voluptuous compliant women. But by the time Gauguin
arrived in Papeete, Tahiti's main town and port, in 1891 virtually all
indigenous culture had been eradicated by Western colonists and
missionaries. The Gauguin legend omits that often he had to work as
a journalist for a French newspaper while he was in Tahiti and sur-
vived not on nature's bounty but on tinned food and biscuits from a
nearby Chinese trading store.

Gauguin's paintings tell the viewer more about the assumptions of
a metropolitan Frenchman than they do about Polynesian culture.
The brightly-coloured fabrics that are said to give a 'tropical' flavour
to many of his paintings were European imports, while many of
Gauguin's 'pagan' women were in fact practising Christians who
would normally have worn demure Westernized dress rather than
the exotic costumes he gave them. Even the 'native' objects and
inscriptions that he depicts surrounding them were often not even

> ❝*Gauguin is always poaching on someone's land; nowadays he's pillaging the savages of Oceania.*❞
>
> Camille Pissarro, artist

Left: Gustavo Mancinelli, *In the Harem* (1875)
Right: Paul Gauguin, *Parau na te Varua ino*
(*Words of the Devil*) (1892)

from Tahiti but taken from contemporary books and photographs purchased on one of Gauguin's frequent visits to the massive Universal Exhibition of 1889 which had presented Paris with an 'ethnographic display' of the peoples of the French Empire on an unprecedented scale. Not only was this colonial Disneyland (which had uprooted entire villages complete with their artefacts and inhabitants) an important inspiration to Gauguin, as well as a potent expression of imperial power, but it also helped to perpetuate the French taste for the 'exotic' and the 'primitive'.

Display from Eduoardo Paolozzi's exhibition 'Lost Magic Kingdoms' at the
Museum of Mankind, London (1987), which juxtaposes two of his sculptured
heads with artefacts from non-Western cultures. A comment on the complex
power relations between Western artists and art from non-Western cultures.

No one could dispute the importance of so-called Primitivism in
the history of modern art: as recently as 1984–5 it has been attested
to in a MOMA exhibition entitled 'Primitivism in 20th Century Art:
Affinity of the Tribal with the Modern'. This show very deliberately
presented African art solely in terms of its stylistic influence on
Western artists – Western artists were named, African pieces
remained anonymous. Whatever the ethics of this particular exhibi-
tion, Primitivism can never be wholly separated from the history of
the domination of much of Africa by a few European nations.

[123]

*❢The noble work of our race, down to its most
insignificant spiritual and physical expressions, is
native (and essentially Indian) in origin . . . the art
of the Mexican people is the most wholesome
spiritual expression in the world, and this tradition is
our greatest treasure.❣*

David Alfaro Siqueiros, artist

In short, while all nations are equal, some are more equal than
others. For example, the nineteenth-century art critic John Ruskin
wrote this: '. . . the reader who has not before turned his attention to
this subject may, however, at first have some difficulty in distin-
guishing between the noble grotesques of these great nations, and
the barbarous grotesque of mere savageness, as seen in the work of
Hindoo and other Indian nations; or, more grossly still, in that . . . of
the Pacific islands.'

Yet it is important not to imply that the colonized cultures simply
lay down and suffered their fate. That would be far from the truth. In
Ceylon (now Sri Lanka), for example, painters formed Group 43 in
1943 to demonstrate that there was an art opposed to 'the existing
colonial convention, exemplified in the imported and orientalized
academicism of the Ceylon Society of Art'. Clearly art can be used
and valued as much by emergent nations as by European ones.

The importance of Aboriginal art in making the original inhabit-
ants of Australia visible and giving them a pride in their own activity
is well known. One can see a related function for art in a country
such as Zimbabwe, with a rich past of which the colonial is far from
the most interesting. Yet the resources with which such a culture
has to work are derisory. Zimbabwe's National Gallery was founded
as recently as the 1950s with a donation of seventeenth-century
European paintings from the Courtauld family and included an
ethnographic section comprising traditional artefacts. It is now try-
ing to build up a collection of contemporary Zimbabwean art which
would be more relevant to the country's nationalist aspirations.

As part of this effort to identify a coherent Zimbabwean aesthetic,
the National Gallery has vigorously promoted Shona stone sculp-

Contemporary stone sculpture
from Zimbabwe: Gladman Zinyeka,
Resting Destitute (1990)

ture as the most important aspect of the country's art. But the fate of
such sculpture shows how difficult it may be for a post-colonial
nation to maintain its identity and integrity in a global art world.
There is a real problem in reconciling local cultural needs with the
very different requirements of the international art world. The
danger is that what started out as a matter of national self-assertion

can very quickly become a marketable commodity for voracious metropolitan art centres. Shona sculpture is now primarily created for and collected by whites and usually sells at prices way beyond the reach of the society for which it was intended. Many local artists view the international mainstream that the gallery is courting as alien to their needs.

The Zimbabwean painter Thakor Patel was already well known in his own country when he visited America in 1987, but it was the time he spent among American artists that, in the words of an exhibition catalogue published after Patel's return home, 'confirmed his purpose and reassured him of [his work's] validity'. Such is the power of the old centres of the art world.

There is no guarantee that national art will flourish in the art world and raise the diplomatic and cultural profile of the nation: it may depend on the political and economic power that can support it. The museum and gallery success of the art of the Australian Aborigines has so far not been echoed in political terms, as was underlined by the Aborigines' protests at Australia's bicentennial in 1988. The fate of much Aboriginal art is to be purchased in bulk by business corporations who use it both as a relatively inexpensive decoration for their offices and also as an effective means to 'liberalize' their image.

But there have been 'national' art successes by small nations, even if they are unrepeatable. After the revolt that ousted dictator 'Baby Doc' Duvalier in 1986, the Haitians painted elaborate murals on their city walls to celebrate a new Haiti. These murals appeared spontaneously and were produced by untrained artists. Being murals they could not be appropriated and robbed of their meaning

Symbolic angel lances a Tonton Macoute on a mural in Port-au-Prince, Haiti, after the revolution of 1986 which ousted 'Baby Doc' and his secret police, the Tonton Macoute.

by the international art market. Sometimes optimistic, sometimes demanding retribution, these works not only bore witness to national solidarity in the face of oppression and a country's hopes for the future, but they also formed important vehicles for communication in a nation where only 10 per cent of the population can read or write.

A combination of tropical climate and renewed turmoil has resulted in the destruction of Haiti's popular murals; perhaps we should see their disappearance as an indication that in order to be truly 'national' or 'revolutionary' and not merely exotic, art now has to be ephemeral. If a nation's art can be bought it can be appropriated, just like the nation itself. If a multinational corporation such as IBM can generate an income equivalent to the annual GNP of a developed nation such as Belgium, what chance does art have of maintaining national identity?

But there may be another solution to these problems which lies in the disappearance of national art altogether. It may seem strange to argue in the middle of a discussion about national art that such an art form may presage less the future than a final fling of the past. But if indeed nationalism cannot thrive in the long term outside the nation state, then, with the decline of the latter, perhaps the former's days (or at least years) are numbered. In any case, much of the most interesting art currently being made is a hybrid of more than one culture. Britain's representative in the 1990 Venice Biennale was Anish Kapoor, a sculptor who carries an Indian passport, has a Hindu father and a Jewish Iraqi mother, and lives in London. Kapoor's work makes a point of using all these parts of himself as resources as well as those of Minimalist and Conceptual art.

[127]

❝A national culture is not a folk-lore, nor an abstract populism that believes that it can discover a people's true nature.❞

Frantz Fanon, *The Wretched of the Earth*

Another important artist in this context is the Haitian painter Patrick Vilaire. From Port-au-Prince he makes massive bronze chairs which fuse elements from voodoo ceremony, French colonial design, and African sculpture with recollections of Surrealist art and the architecture of Antoni Gaudí. Vilaire's significance here is that he neither accepts the terms of reference laid down for him by European art nor tries to retreat from them into some indigenous national tradition suppressed by colonialism. His is a hybrid art, a truly post-colonial art.

Vilaire was one of the artists participating in 'Magiciens de la Terre', perhaps the first truly global exhibition, held in Paris in 1989. It attempted to remove the divisions between Western and non-Western art by showing well-known figures from major art centres alongside those from normally peripheral locations such as Haiti, India, Madagascar and Panama. In an attempt to sidestep the pitfalls of ethnography or the romanticization of the exotic, and to avoid giving art a 'national' bias, the exhibition organizers laid special emphasis on societies in transition and the cross-fertilization of different cultures.

Yet many did not see the exhibition in this way. While 'Magiciens' was acknowledged as being less patronizing than MOMA's 'Primitivism' show of three years before, it nevertheless aroused as much controversy. The curatorial decision to give all works equal treatment by labelling both commercial Western art and traditional religious and ceremonial structures from other cultures with just the name of the artist and the geographical origin was seen as an (albeit unintentional) encouragement to apply Western aesthetic standards to objects which had nothing to do with such an interpretation.

Metal chair by the Haitian artist
Patrick Vilaire (1989)

> **❛Being an artist today is about
> the world of culture generally.❜**
>
> Anish Kapoor, artist

Many critics felt that the context of the works, or their ritual
purpose, should have been provided when relevant. For many the
show simply perpetuated Western culture's proprietary attitude
towards the rest of the world and resembled, in its combination of
exhibits such as the carved house containing a Buddhist mandala
from Nepal, the façade of a Benin voodoo house from Nigeria, an
Aboriginal sand painting and burial totems from Madagascar,
nothing more than an updated version of the Universal Exhibition
which had enthralled Gauguin a hundred years before.

'Globalization' may be viewed as a preferable substitute to
nationalism in art, but as a notion it is equally problematic to define
and to achieve. What, for example, is the difference between Italian
artist Mario Merz incorporating a woven straw hut into his sculpture
and Picasso's use of African masks? When Francesco Clemente
employs Indian miniaturists to paint pictures under his name to be
sold in metropolitan centres of commercial art, are his actions any
less 'colonial' than the European collectors of Benin bronzes? Do
the shadow-throwing tin skeletons of French artist Christian
Boltanski show the same 'cultural cross-fertilization' as the
Mercedes-shaped coffins made and sold by Ghanaian Kane Kwei?
In exhibitions such as 'Magiciens de la Terre', when a mud circle by
British artist Richard Long is juxtaposed with an Aboriginal sand
painting, whose image is it anyway?

5

The Shrine

Walk around a museum and then a zoo. Can you spot any similarities? Aren't the paintings, trapped inside galleries, with their explanatory labels, rather like the animals imprisoned in well-meaning but unsuitable surroundings? And don't we, as visitors, have the same kinds of feelings in the two places – gratitude that we can actually see things which we would not be able to without the existence of such places and a lingering recognition that they nevertheless change the nature of the creatures they hold captive – and that their occupants ought to be allowed to go free and resume their former life? Or, in the case of the museums, have we become so accustomed to them that we have forgotten that art ever had any other home? Certainly art exists which has been born and bred for the museum and for which no other life can be imagined.

It could be argued that museums are the central focus for all the sections of the art world described in other chapters. Artists yearn to have their works bought and placed in the collections of the major museums and the most fortunate of them will be interred in museums of their own after their death. Dealers may well be able to get a better price for works from a collector, but prestige accrues to those commercial galleries which are intimate with the major international art museums. 'Museum quality' is a common phrase used by dealers to emphasize the importance of a piece. Collectors may be wooed by museums to leave them their trophies, and it is still a matter of honour to be asked to serve on museum boards. If imitation is the most perfect form of flattery, then the museums and galleries founded by collectors such as Paul Getty and Charles Saatchi are signs that the aura of museums still burns brightly.

Neither has the prestige of museums diminished for Western governments which seem to compete to make their major cities museum centres of the world. Has France now recovered the title from the USA? Has Britain ambitions in that direction? The British government showed enough awareness of the significance of museums in 1988 to place an unsuccessful bid of £100 million to obtain the Thyssen-Bornemisza collection for the nation, and to promise to build a special home for it. In the same year, Governor Michael Dukakis (perhaps as part of his campaign to raise his profile for the forthcoming presidential election?) pledged $35 million of state funding for the creation of a Museum of Contemporary Art and Architecture complex in the depressed town of North Adams, Massachusetts.

Museums and art galleries are profoundly important places for placing value on those objects without which they would make no sense: paintings and sculpture. And yet museums do not simply house such objects – they transform them into art with its own aesthetic identity. Inside a museum of art, any object, however mundane or utilitarian, is potentially an art object. On show in New York's Museum of Modern Art are a Braun coffee grinder and an Olivetti typewriter. Their functions are irrelevant: what matters is that they are aesthetic objects.

Once they are part of the museum system the most unlikely objects become respectable. The Italian Piero Manzoni's canned faeces are exhibited worldwide as an important part of the *Arte Povera* movement; the Tate Gallery struggles to preserve the crumbling burnt books and assembled detritus on its two John Latham wall reliefs. The museum is happily able to accommodate

*'Museum and mausoleum are connected
by more than phonetic association. Museums are
the family sepulchres of works of art.'*
Theodor Adorno

The Great Hall of the
Metropolitan Museum of
Art, New York, in the
1920s, then in the
process of becoming the
greatest treasure house in
the world.

Joseph Beuys, *Untitled*, felt sculpture (1985)

even the anti-museum work of Marcel Duchamp. In 1917 Duchamp, an advocate of Dada, a movement bitterly opposed to the sanctification associated with museum exhibits, submitted a urinal for exhibition under the title of *Fountain* and signed 'R. Mutt' (see page 8). Subsequently it has been incorporated into museum exhibitions of Dada. Clearly the museum is not easily offended.

Duchamp's 'ready-mades' (which also included a metal wine räck and a bicycle wheel mounted on to a wooden stool) were also forerunners of that art which makes the context of the museum part of the meaning of the artwork. Warhol's Brillo boxes, Carl Andre's neatly stacked firebricks or Joseph Beuys' rolls of felt and piles of

animal fat (which he exhibited from the 1960s until his death in 1986) need the context of the museum to be recognized as art, otherwise they would simply be boxes, bricks, felt and fat. The museum is the signal that such work should be read in a particular way – not functionally but aesthetically.

Museums of modern art are so closely involved with their exhibits that they construct the story of art which they purport merely to collect and preserve. When the quintessential modern museum, the Museum of Modern Art, was founded in New York in 1929, 'Museum' and 'Modern Art' were still regarded as incompatible. No European museum was systematically collecting modern art and it was the norm amongst avant-garde artists of all persuasions to dismiss museums as symbols of an obsolete past: 'Museums are just a lot of lies,' Picasso declared.

A new precedent was set by the pioneering attitude of MOMA's first Director, Alfred H. Barr Jr, whose policies had a direct influence both on museums of modern art and on modern art in general. Barr saw Modernism as a historical fact rather than a series of freakish occurrences. He was therefore determined to establish a pantheon to this contemporary culture both by obtaining the best examples from all the different factions (however opposed to each other they might have been), and by extending the museum's scope to reflect the interest of modern art in photography, film, industrial design and architecture. MOMA's acquisition policy and exhibition programme has largely remained true to these aims – the art has shaped the museum and vice versa. This symbiotic relationship has made MOMA itself a key part of twentieth-century art history, as well as being responsible for historicizing modern art. Small

*❝These collections tell the story of modern art.
They have been instrumental in introducing the art
of our time into the mainstream of cultural life.❞*

MOMA statement on its reopening on 7 May 1984

wonder that it promotes its own stature as a temple of Modernism.

But it is important to stress that museums transform not only mass-produced or avant-garde objects, but objects of other kinds which we now recognize as art. A Renaissance altarpiece is no longer part of a Christian ritual when it hangs in a gallery alongside a dozen other Renaissance altarpieces, while many of the paintings and sculptures that we see in museums – whether Egyptian mummy portraits or medieval icons – no longer serve their original function of commemorating and celebrating the individuals they depict, having been wrenched from the surroundings for which they were made. The effects on objects from 'Third World' cultures are equally drastic. One museum response to such objects has been to found ethnographic institutions which present such objects as a 'cabinet of curiosities'. The other has been to allow some of these objects through the art museum gates either on the grounds of their aesthetic beauty or of their contribution to Western art. The 1984–5 MOMA show 'Primitivism in 20th Century Art' appropriated African objects as part of the story of modern Western art, somewhere between Cézanne and Picasso, and on the road to Jackson Pollock.

Perhaps the oil paintings of the Old Masters are more at home in museums? Yet they appear aloof, guarded by attendants and shrouded in the mystique that emanates from their rarity and preciousness. It does not matter that most visitors to the Louvre are already familiar with the image of the *Mona Lisa*, they come to pay homage to the original. The fact that the painting can barely be seen through the crowds and protective barriers only adds to its mystique. Paintings in such circumstances are made to transcend

*6A fundamental fault with nearly all art galleries,
certainly with the major ones, is that they are
designed to deal with quantity. The architects
are engaged to provide what are in essence
filing cabinets or stamp albums. It is a profoundly
unnatural and misguided activity.9*

Kenneth Hudson

history. The assumption is that you need to know nothing about Leonardo da Vinci, the conventions of Renaissance painting or of ideas of the Renaissance, to understand the most famous painting in the world. You are there to worship in respectful silence (if with aching legs), and to take back to the world outside some of the beauty found within.

The way that paintings and other art objects are perceived is shaped by the procedure for viewing art that applies in almost every museum. Touching the exhibits is forbidden (the *Mona Lisa* is shielded behind bullet-proof glass), close proximity is discouraged and loud conversation unwelcome. Visitors progress slowly through a sequence of rooms (gallery diagrams often advise a particular route), with frequent pauses to examine each piece and to read its accompanying label. Rooms containing particularly large or important works are often furnished with specially-designed benches to enable more lengthy scrutiny without obstructing other visitors who may prefer to keep moving.

Although things look different in a modern art gallery (or as it has been widely dubbed: 'the white cube'), it too insists upon a specific frame of mind. Deprived not simply of all distraction but of a context for the art other than the space that it is in, the visitor attends to the art object in its own right, which is placed, icon-like, in its own space against the dazzling white wall. And in that brilliant space does not anything that is displayed appear to be art? Hanging is no more neutral than any other aspect of the art world. It is only necessary to see the way paintings were hung in nineteenth-century salons – densely, from floor to ceiling, without reference to genre – to recognize that hanging helps to shape the visitor's response to the

'A picture gallery appears to be thought of as a fair
whereas what it should be is a temple, a
temple where in silent and unspeaking humility
and inspiring solitude, one may admire artists
as the highest among mortals.'

W. G. Wackenrode, 1797

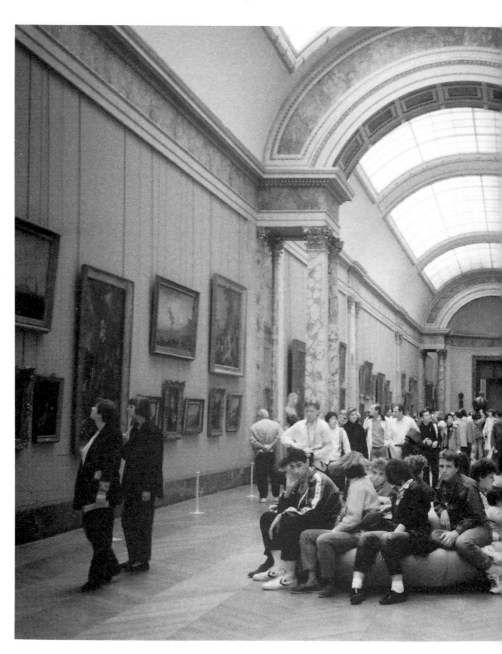

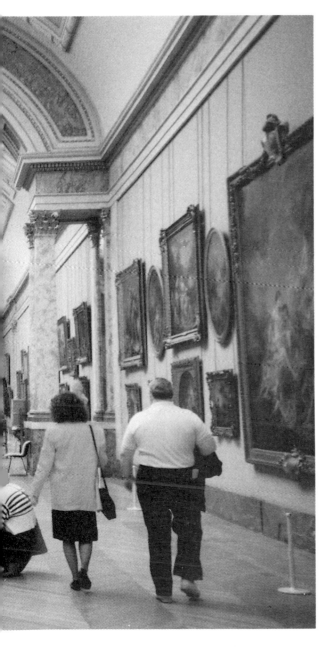

Exhausted visitors at the Louvre. Is this the museum experience?

*❛Manet's barmaid, a Degas ballerina – all are
gleefully slashed. Behind him, The Joker's
ugly goons have their work cut out for them,
spraying paint on every canvas their boss man
missed. He finally stops at Edward Munch's*
The Scream *and cocks an eyebrow. "I kinda
like this one. Leave it."❜*

Batman: the Art of Crime.

art, as of course does framing too. Put a painting in a gold frame and
the visitor will look at it differently – although what does such a
frame signify other than that the owner had money and the picture
has a pedigree?

All this ritual surrounding revered objects is in keeping with the
dominant image of a museum as a temple of art. Since the last cen-
tury art has been seen as a source of moral as well as intellectual
improvement; as the power of religion has declined, that of art has
increased. In 1881, an Anglican vicar organized the first 'Fine Art
Exhibition' for the poor in London's Whitechapel, causing an out-
cry by remaining open (and attracting large crowds) on Sundays.
The success of this annual event encouraged Parliament in 1896 to
recommend that all museums be open on Sunday afternoons; while
in New York Sunday openings came to the Metropolitan Museum in
1891 amidst fierce opposition from religious groups. Today more
people visit museums on Sunday afternoons than at any other
time. During March 1990 the Tate Gallery regularly recorded
average attendance figures of nearly 5000 between 2 and 6 p.m. on
Sundays, just slightly less than the average attendance on any eight-
hour day that month.

The architectural style of museum building also often promotes a
spirit of reverence and devotion to the artworks as well as incarnat-
ing the importance of the artists and benefactors. When Sir John
Soane designed Dulwich Picture Gallery in 1811–14 he made its
focal point the domed neo-classical mausoleum which contains
the bodies of the founders and suffuses the entire building with a
sombre air. One of the devices used in Karl Friedrich Schinkel's
Altes Museum in Berlin to ensure 'a mood of sacred solemnity'

THE SHRINE

The J. Paul Getty Museum, Malibu, California.
A temple where all may come to worship.

Left: Pressure for Sunday opening at the Metropolitan
Museum in New York from *Puck* magazine, 1889
Right: A party of working men visiting the National
Gallery, London, 1870.

THE METROPOLITAN MUSEUM.

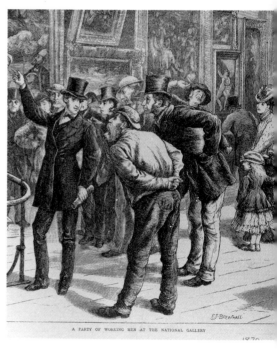

A PARTY OF WORKING MEN AT THE NATIONAL GALLERY

was to place classical sculptures on exceptionally tall pedestals.

But temples, because of their sacredness, invite desecration.
Accompanying the elevated status of museums and the artworks
they contain is the increase of physical attacks on these institutions
and their contents. Putting aside straightforward theft (such as the
fourfold disappearance of Dulwich Picture Gallery's Rembrandt
portrait of Jacob de Gheyn III) or a violent reaction to a specific
work (accusations of sexism prompted the 1986 pouring of
paintstripper on to Allen Jones's sculpture *Chair* in the Tate

*❛We want to destroy museums, libraries,
and academies of all kinds.❜*
First Futurist Manifesto, 1909

Gallery), these 'art attacks' reflect the fact that the gravitas of museums and the art that they contain are an invitation to profanity.

The art dealer Tony Shafrazi made headlines in 1974 when he defaced Picasso's *Guernica* with graffiti in the Museum of Modern Art, New York, to underline the museum's discrimination against graffiti artists. In 1982 a homeless eighteen-year-old slashed paintings by Turner and Claude in the National Gallery in London, while ex-soldier Robert Cambridge expressed his objections to the political status quo in 1987 by shooting bullets into Leonardo da Vinci's *Virgin and Child with St Anne and St John the Baptist* in the same gallery. In the 1989 film of *Batman*, the Joker reaffirmed his evil reputation by wreaking havoc not in Gotham City's cathedral (which was presented as derelict), but by systematically vandalizing the 'masterpieces' in its vast museum.

The museum as temple is now, however, challenged by the museum as mass spectacle. These new pleasure-domes have their origins in the marketing tactics, blockbuster exhibitions and self-promotion developed by museums over the last decade; and they present art as part of the entertainment industry.

Museum visitors now expect to enjoy the surroundings as much as the art. Although the Trustees of New York's MOMA turned down Alfred H. Barr's intention in 1936 that only a leading architect of the day was worthy of designing a museum of modern art (he put forward a line-up of Mies Van der Rohe, J. J. P. Oud or Walter Gropius) and instead gave the commission to two relatively conventional American architects, Philip L. Goodwin and Edward Durell Stone, this principle has become today's prototype. Much of the appeal of the new Massachusetts Museum of Contemporary Art and

Architecture in North Adams is that it is to be housed not just in a vast complex of nineteenth-century industrial buildings but that their conversion is to be carried out by the fashionable architects Bob Venturi and Frank Gehry. The museum building now rivals the art inside as an aesthetic object.

When the Gare d'Orsay in Paris was converted into the Musée d'Orsay, the exhibits were made to work as an integral part of the building. The decision to rehouse the Impressionist collection from the Musée Jeu de Paume and many of the Louvre's nineteenth-century French paintings in the disused Orsay railway station marked a new approach to the presentation of art: France's industrial as well as its artistic achievements were to go on show. Throughout the Musée d'Orsay, a concerted effort has been made to acknowledge its original function as a railway station and to accentuate its scale and structure. The main train shed is left intact as a steel and glass barrel vault which arches for an uninterrupted 103 feet above the floor, and covers an area which could accommodate the Garden Hall of MOMA, the walkways of the Pompidou Centre and the East Building of the National Gallery of Art in Washington D.C., all at the same time. Visitors moving through the museum are deliberately brought into close contact with its exposed joists, piers and large station clocks, and from balconies high up in the central hall can look out across Paris.

Art now has to compete with the museum's other crowd-attracting assets. The Musée d'Orsay offers not only a spectacular building, but sections of Métro stations, interiors of rooms, computer-generated images of paintings and scale models of Second Empire Paris. Some of the paintings are arranged in roofless cubicles that follow

the axis of the original railway tracks and platforms; but the Impressionist galleries can only be reached by a series of escalators since they are set to one side of the building in order not to interrupt the impact of the central nave. Crowds of tourists mean that the museum becomes noisy and dynamic and more like a theme park than a temple. Pleasure rather than education becomes the presiding principle.

Even MOMA, that temple to Modernism and serious reflection, when it reopened in summer 1984 after a four-year period of expansion and refurbishment, confirmed that no museum can fail to acknowledge that it is now in the business of mass entertainment. MOMA emerged as a museum specifically designed to hold huge crowds of people, enabling it to accommodate a new phase of highly publicized 'blockbuster' exhibitions that had begun with MOMA's mammoth Picasso Retrospective of the spring–summer of 1980. This filled the entire old museum building, attracting over 7000 visitors a day, and required a special system of advance reservation, new methods of controlling the crowds, as well as an enlarged publicity department to keep the crowds coming. In MOMA and museums across the world this was to be the new, standard practice.

But as important as the new design's way of facilitating the movement of large crowds is its celebration of the status of the museum itself. The vast glass atrium of MOMA's Garden Hall dwarfs the token pieces of art on show, but presents visitors with a dramatic place to meet and take in the atmosphere of the museum without actually having to look at art. Banks of escalators provide a view of museum and city alike, while scale is emphasized by the Sikorsky helicopter dangling overhead. It is this space rather than the

James Stirling's extension to the Staatsgalerie
in Stuttgart (1977–83). Is the museum itself
now a work of art?

increased gallery capacity which impresses MOMA's visitors. In a similar way visitors, rather than artworks, populate the vast nave that dominates I. M. Pei's East Building of the National Gallery of Art in Washington D.C.; while large crowds assemble to admire the view from the panoramic glass walkways of the Pompidou Centre in Paris. From J. Paul Getty's facsimile of a Herculaneum villa in Malibu to the glass pyramids and red stone masses of Arata Isozaki's 1982 Museum of Contemporary Art in downtown Los Angeles, museums now rival the art they display as the real objects of reverence.

The most prominent art exhibits in a museum are no longer necessarily its masterpieces: visual impact is now given equal priority. In a Post-Modern determination to present an all-encompassing view of culture between 1848 and 1914, and to avoid previous art-historical hierarchies, the Musée d'Orsay has resurrected the official academic art of the nineteenth century. And since these forgotten pieces tend to be more flamboyant than the Impressionists and their predecessors, they have been given a high profile within the building's massive spaces. The visitor first encounters the art of the Musée d'Orsay alongside its main entrance, where queues form amongst the huge bronze sculptures of exotic animals and female personifications of continents that once decorated the Palais de Trocadéro. Inside, along the length of the central nave, is a procession of forgotten academic sculptures which are now given the limelight after decades of obscurity. In certain ways the museum leaves the issue of valuation open. What does Manet's *Olympia* have in common with Mathurin Moreau's hefty bronze *Oceanis*? Which is now the more important, Thomas Couture's massive canvas of

The Pompidou Centre, Paris.
Is it the place rather than
the art which is a crowd-puller?

Romans of the Decadence or Gustave Courbet's *Burial at Ornans*?
Inside the Musée d'Orsay all receive equal billing. Museums like the
d'Orsay make it impossible to revere artworks as isolated icons,
instead they become part of the spectacle.

Shopping and eating are recognized to be as central to a museum
visit as art appreciation. Museum shops and restaurants are no

Advertisement for the shop
at the Metropolitan Museum,
New York

...the ideal way to buy
your presents from
The Metropolitan Museum

Every three months—four times a year—the Museum will announce
by mail remarkable new replicas—exact copies of Museum originals:
sculpture, decorative objects, tableware, and ornaments.

The variety will be extraordinary: ancient jewelry in gold and sil-
ver; Oriental and European porcelain; early American glass in crystal
and rare colors; bronze from Egypt, Greece, China, and the medieval
world; silver, pewter, brass, and pottery from Colonial America.

These copies, often produced by the same techniques used for
the originals, are made by artist-craftsmen working under the Mu-
seum's direct supervision. The care taken in production frequently
limits the quantity, and the majority of replicas can be bought only by
mail or at the Museum. (Above: Hippopotamus, brilliant blue faience
decorated with lotus flowers. Length 8", $19.75 plus $1.25 shipping.)

To receive all of the advance announcements to be issued during
the next year, send the coupon below with one dollar to cover mailing.

On September 1, you will receive the first of these, the 116 page Christmas
Catalogue. A brilliant array of new presents includes an ancient Egyptian
necklace of blue lotus flowers; golden stags, panthers, lions, and griffins
from the Scythian treasure hoard; needlework kits of a tiger from a Chi-
nese ceremonial banner, and puppies and kittens from a New England rug;
a rose and a star in stained glass; a book of Persian miniatures in full color
and gold; a bronze Etruscan acrobat; *art nouveau* stationery; a new cook-
book, *To the King's Taste*, and next year's engagement calendar, *Secret
Gardens*. In addition, there is an unparalleled selection of Christmas cards.

THE METROPOLITAN MUSEUM OF ART
255 Gracie Station, New York 10028 N2

Please send me all advance announcements and catalogues of replicas to be
issued by the Museum during the next 12 months. One dollar to cover mail-
ing costs is enclosed.

NAME _____

ADDRESS _____

_____ ZIP _____

THE SHRINE ▰

❛When you think of it,
department stores are
kind of like museums. ❜

Andy Warhol

Cartoon about the Hayward Gallery, London,
from the *Architect's Journal*, 15 March 1989

HAYWARD ART GALLERY... HMM, DEFINITELY RINGS A BELL ... I'M SURE IT'S AROUND HERE SOMEWHERE ...!

longer just an additional source of revenue, they encourage visitors
in their own right. Hence the Victoria and Albert Museum's 1988
advertising campaign to promote itself as 'An Ace Caff – with quite a
nice museum attached'. Every major museum now has extensive
catering facilities as well as a shopping centre where the art of its
collections can be purchased, not just in facsimile, but also repro-
duced in every conceivable form. On postcards and paperweights,
T-shirts and tote bags, art is marketed by museums as another
consumable commodity. Jenny Holzer is one artist whose work has
taken advantage of these new vehicles for art: over the years her
terse slogans have reached a wide audience by being printed on to

Opposite: Massachusetts Museum of Contemporary Art –
architect's plan and bridge linking two buildings.
Is this the shape of the museum of the future?

stickers, T-shirts and baseball caps. Fellow American Barbara
Kruger's photomontage bearing the aphorism 'I shop therefore I
am' is currently for sale in museums throughout the world, printed
on to canvas shoulder-bags.

Museums are especially ingenious in using the prestige that art
can command to commercial advantage. Rooms full of Rembrandts,
Raphael cartoons and even the Elgin Marbles can now be hired,
complete with their attendants, as decorative venues for private
parties, and it is common practice for museums to collaborate with
travel agents to organize overseas trips focused around their collec-
tions. Both museums and their art are an important part of the tour-
ist trade.

It was strictly commercial considerations that lay behind the
establishment of the world's largest contemporary art museum.
Massachusetts Museum of Contemporary Art and Architecture
(known as Mass MOCA) is not restricted to one building but
occupies an entire complex covering more than thirteen acres. The
site had previously housed Sprague Technologies Inc. which pro-
vided the main source of income and employment for North Adams,
Massachusetts, until 1986 when the plant closed and the town's
unemployment rate doubled. A museum (especially one of contem-
porary art) might seem an unexpected solution to the town's
financial doldrums, but Mass MOCA, scheduled to open in June
1993, is seen as much as a business venture which emphasizes
urban renewal as a centre for contemporary art. Nearly a third of the
package comprises shops, restaurants, condominiums, a convention
centre and performance space which integrate with the area allo-
cated to artworks. Just as the Tate Gallery in Liverpool formed the

[154]

GROUND FLOOR PLAN

focus of the Albert Dock refurbishment and inner city regeneration (at least that was the plan), so Mass MOCA is proposed as the catalyst for the commercial revitalization of a small mill town. The local enthusiasm and a large state grant attracted by Mass MOCA does not indicate a newfound interest in contemporary art. It is a declaration of faith in the mass tourism that this theme park-museum will attract. With careful marketing, even traditionally inaccessible contemporary art can become part of the entertainment industry.

In Mass MOCA, size and spectacle will be used to make contemporary art into a crowd-puller. The museum breaks new ground by specializing in work that is too massive for normal gallery spaces and can provide a context that matches the epic dimensions preferred by many of today's artists. Already earmarked are sculptor Donald Judd's 47-foot-long row of hot-rolled steel cubes, three 280-foot strips of yellow and pink neon by Bruce Nauman and four of Richard Serra's huge steel plates. Mass MOCA has the space: half a million square feet of it. Just one building has 40,000 square feet on each of its three floors, whereas the entire exhibition space of New York's Whitney Museum, which specializes in displays of contemporary art, only adds up to 25,000 square feet.

Mass MOCA will not own the artworks in its massive galleries – it could never afford them. Instead, the exhibits will belong to the world's major collectors, other museums and even the artists themselves, with Mass MOCA offering spectacular spaces for space-hungry work. Some of the art on show may even be for sale. In contrast to Alfred H. Barr's view that a museum of modern art should be comprehensive, Mass MOCA is unashamedly selective. Size is inevitably a consideration and although the work of only fifty artists

❝*Some art historians take French;
I studied computers and business.*❞
Thomas Krens, Director, Guggenheim Museum and Mass MOCA

will be shown, most of these are represented by a number of career-spanning works. Mass MOCA acknowledges the fact that museums are no longer the main purchasers of art: it relies on its unique format and dimensions to attract not just its audience but also its art.

As museums expand into the mass market they have followed the lead of every other large-scale business by calling on the assistance of technology. In today's museums you are simultaneously surveyed and serviced, it is impossible to look at art without yourself being examined. Museum-goers are monitored by security cameras while they are simultaneously fed additional information from video monitors, taped messages and computer banks. Artists themselves recognize the ambiguous relationship between artworks and the technology which purports to protect and enhance them. During the 1989 Whitney Biennial, Julia Sher's alternative surveillance system for the Whitney Museum enabled visitors to watch themselves circulate through various parts of the building and to take away a photographic record of their presence in the form of a video print-out. Sher's installation blended so effectively into its surroundings that many visitors took it to be the real thing.

The sophistication of its equipment can safeguard a museum's reputation. No one respects a museum which cannot save its pictures from theft or vandalism, and museum audiences like to view paintings in a bright, well-restored state. Even before it opened, Mass MOCA was promoting itself as 'the most technologically advanced museum in the world'. Mass MOCA's director Thomas Krens aims to make technology one of the museum's most valuable assets and its staff have been working with a nearby computer college to develop the most advanced apparatus available. With

televised surveillance systems replacing museum attendants, computer databases covering the artists' other works and large-scale, high-definition TV screens scattered throughout the museum complex, both art and audience are electronically controlled.

Whether as high-tech theme park or venerable temple, the museum dominates our cultural landscape and shapes how we see the visual arts. Its impact is especially remarkable since the museum is a relatively recent invention which did not exist until the eighteenth century. Even then the museum had inauspicious beginnings. It was only mounting public criticism of his lavish expenditure that forced Louis XV of France in 1750 to remove a portion of his royal art collection from his palace at Versailles and put it on public view in the Palais du Luxembourg for two days a week. But this imposed altruism was short-lived: just as Parisian art lovers developed a taste for the royal Raphaels, Rembrandts, Titians and Leonardos, the Palais was given to one of Louis XVI's brothers who closed it to the public. It took the French Revolution to make France's oldest royal palace into the first public gallery: in 1793 the first national public gallery opened in the Louvre.

From the beginning it was recognized that museums had the power to change the way art is seen and that this could be turned to political advantage. After the French Revolution the royal collections, as well as an immense quantity of art treasures taken from France's churches and abbeys, had to be accommodated. While many revolutionaries saw these *objets d'art* as symbols of the decadent *ancien régime*, many more did not want to be regarded as ignorant vandals who had destroyed France's artistic heritage. It was decided that only the context of the Musée du Louvre could purge

■■■ THE SHRINE ■■■

Samuel F. B. Morse, *Gallery of the Louvre* (1831–3).
Art from different times and places has been brought
into the museum – but is this where art belongs?

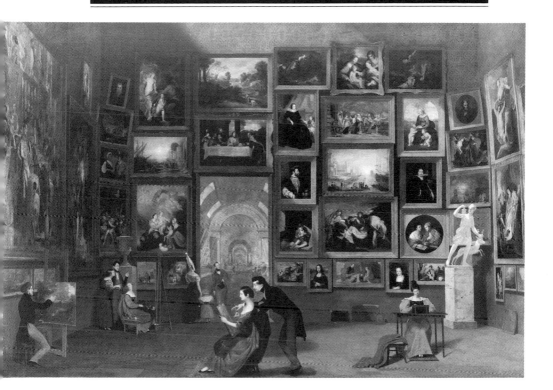

this pre-Revolutionary art of its pernicious contents and make it
safe for public consumption. This belief swelled the collections of
the Louvre as Napoleon swept through Europe with his armies. A
system of organized pillage removed the art of former ages from the
palaces of princes and prelates and transferred it to the Louvre
where it could be taken to the people and presented in a healthy
Republican light. When the Louvre ran out of space fifteen more

[159]

galleries of art were established throughout France to show the overflow in a similarly favourable context.

Museums have continued to serve this legitimizing function. In the nineteenth century they provided one of the few socially acceptable contexts where it was possible to gaze at exposed female flesh. In this century the sponsorship of museums and their blockbuster exhibitions has become such a widespread policy of large business corporations that museums have come to rely on their support to supplement dwindling government grants. The 1990 rehang of the Tate Gallery was sponsored by British Petroleum; there was much controversy surrounding the Tate's 1986 Stubbs exhibition because it was sponsored by an arms manufacturer, United Technologies Ltd. The German-born artist Hans Haacke analyses in his work the business interests and social status of contemporary art's major sponsors (see pages 90 and 97) and as a result he is not collected by any major art institution.

However comprehensive they try to be, the collections of museums are always shaped by particular assumptions, but this fact is rarely acknowledged. The Louvre may have aimed to represent the best examples of each artistic style and the greatest works of every major artist, but it inevitably gave a very particular view of art and art history: contemporary Neo-classical taste meant that the medieval pieces in the church collections were dismissed as unimportant and barbaric in style; anti-royalist sentiments put at risk any work that depicted past monarchs, while amongst the Italian paintings collected for display in Paris the works of fifteenth-century artists were passed over in favour of popular figures such as Raphael, Correggio, Titian and Veronese. The chaotic circumstances of war

6The modern art museum treats visitors like interns in a hospital, and this is no substitute for the social function that art has always had. It is absurd that artists should create works of art directly for a museum. That creates a short circuit which is tantamount to signing the death warrant of what we call art.9

Gérard Régnier, Director, Picasso Museum, Paris

and revolution were also responsible for the logic of the collection: works were overlooked, damaged and lost. Personal interest also played its part: when Joseph Bonaparte, Napoleon's brother, became King of Spain in 1808, he refused to give the Louvre any treasures from his newly-acquired Prado Palace.

Museums are now so well established that their very particular way of presenting art seems the obvious one. And yet of course it isn't. In a museum art is just art – and the responsibility of the visitor is to respond to these aesthetic objects in an appropriate fashion. But to respond to them in this way means that you have to have the knowledge to be able to decode the paintings, a knowledge that a large part of the public does not have. Museums are for the true believers and the agnostics are left to their own devices. Neither the temple of art, nor for that matter the artistic theme park, attempts to indicate the original function of its artworks or to invite the visitor to understand that what they are seeing was rarely made to be seen in such circumstances, that the art often had functions other than the aesthetic one insisted upon by museums, and that it is perfectly permissible to think of art as a particular craft with certain skills. Perhaps, after all, the museum is the mausoleum rather than the midwife of art.

Afterword

aving reached this point in the book the impatient reader might ask: don't you realize the consequences of your argument? If you say that the meaning and value of art is relative, don't you play into the hands of those who regard some art as a con? Doesn't the belief that 'art' and 'artist' can mean different things at different times in history deprive art of one of its most powerful defences without substituting any better ones? The English politician Norman Tebbit once claimed that there wasn't any real difference between looking at a naked woman in a tabloid newspaper and looking at a painting of a nude in an art gallery. Surely the arguments in this book give ammunition to those who hold such views?

No doubt there are risks in claiming that art, its meaning and value, are made, unmade and remade throughout history. But if there is danger in acknowledging this, there are also advantages. The most important is that it allows present attitudes to art to be challenged. One of today's doctrines is particularly damaging: the identification and celebration of art as a special kind of experience. The various elements of the art world sustains the sense that a work of art is an aesthetic object with its own specific properties and effects of beauty, harmony and form.

Museums separate and enshrine the aesthetic properties of all artworks, whatever their original purpose, by ensuring that their value is not debased by contact with objects lacking this exclusive glamour. The market needs art to remain a distinct and specialized category uncontaminated by the wider social world, even as it allows more and more carefully sifted, sorted and graded objects to be classified as art. Collectors and patrons who have made their wealth

in other areas of life need art to be a protected species which can provide them with status and aesthetic experiences that their money-making activities cannot deliver. And if the artists themselves can't claim that they are special people making unique kinds of objects, then what respect can they command from the rest of us? In a world where usefulness is all, the value of art lies in the fact that it has no specific function. It *does* nothing but simply *is*.

One reaction to this orthodoxy, and one which has been particularly popular amongst radical critics, is the substitution of the aesthetic principle with the political. Sometimes this argument has taken the form that art should be political and at the disposal of certain oppressed social groups. At other times it has taken the form that all art, whatever its intention, is political at one level or another. The content of a work of art, the formal choices the artist makes, the role of the patron, the social location of the artist, all or any of these factors are said to constitute evidence for the case that all art is political. But to make this argument is simply to oppose one simplistic principle with another.

By letting the light of history shine through such orthodoxies this book has attempted to show how objects that have been called art have served many more functions than either the political or the aesthetic. To rehearse some of the roles which painting alone has assumed reveals the paucity of imagination of those who can see art only in these terms. Painting has been (and is) used as a form of record, both public and private; as a form of public commemoration; as a dimension of religious devotion; as an investigation into the power and pleasure of colour and pattern; even as a means of therapy for the mentally ill. The objects we call art have been made

both collectively, and in relative isolation; commissioned by kings and corporations or made for personal solace in the face of individual disaster.

Such a rehearsal is meant only to remind us of some of the uses of art: it could not possibly stand in for a full-scale description of the conditions within which art has been made. To defend art in these terms is to restore the social character to the objects that we call art – but there are costs. According to this argument, art isn't separated from social life but is an integral part of it, and thus has to give up its claim to exceptionality. For example, it may be that visual and emotional concerns found in art can also be experienced simply by looking at a natural landscape or can be discovered in certain practices that we now categorize as 'craft', such as weaving. And aren't there occasions when we wish to speak less of the beauty of art and more of its power to comment on the world?

Of course none of this can be brought into being simply by wishing it – or even saying it. If a look at the history of art shows anything it is that art is less a succession of objects than a practice carried out under certain conditions and with certain purposes. A book, however persuasive its argument, cannot abolish those conditions and purposes. But what it can do is enquire into the dominant definition of art and show how fragile it is. If *Relative Values* has done that, then it has done what we intended. You can see the current orthodoxy one way and you can also see it another. The sense that it might be different is the first step in making it so.

Works Consulted

Chapter 1 The Agony and the Ecstasy

Michael Baxendall, *Painting and Experience in Fifteenth Century Italy*,
 Oxford University Press, 1988
John Berger, *Permanent Red: Essays in Seeing*, Methuen, 1960
Leo Braudy, *The Frenzy of Renown. Fame and its History*, Oxford
 University Press, 1987
Francis Haskell, 'The Old Masters in Nineteenth-Century French
 Painting', *Past and Present in Art and Taste, Selected Essays*, Yale
 University Press, 1987
Robert Hughes, 'The Artist as Entrepreneur', *Modern Painters*, Vol.I,
 No.1, Spring 1988
Richard Kearney, *Wake of the Imagination*, Hutchinson, 1988
Linda Nochlin, 'Why have there been no great Women Artists?', in
 T. B. Hess and E. C. Baker (eds), *Art and Sexual Politics*, Collier-
 Macmillan, 1973
Rozsika Parker and Griselda Pollock, *Old Mistresses, Women, Art and
 Ideology*, Pandora Press, 1981
Griselda Pollock, 'Agency and the Avant-Garde', *Block*, Spring 1989
Janet Wolff, *The Social Production of Art*, Macmillan Education Ltd,
 1981

Chapter 2 The Colour of Money

Richard Cork, 'Art with a capital $', *The Listener*, December 1989
Colin Gleadell, 'Auction Trends in the Eighties', *Art International*,
 Winter 1989
Colin Gleadell, 'Salerooms', *Art Monthly*, Dec–Jan 1989–90
Robert Hughes, 'Sold', *Time Magazine*, 27 November 1989
Robert Hughes, 'On Art and Money', Harold Rosenberg Lecture
 reproduced in *Art Monthly*, November 1984
Geraldine Keen, *The Sale of Works of Art*, Nelson, 1971

John Richardson, 'Picasso Pentimento', *Vanity Fair*, December 1989
Janet Wolff, op. cit.

Chapter 3 The Power and the Glory
Joseph Alsop, *The Rare Art Traditions: The History of Art Collecting*,
 Thames & Hudson, 1982
Art at Work: The Chase Manhattan Collection, Chase Manhattan
 Corporation, 1984
'The Art News 200', a checklist of 200 leading collectors, *Art News*,
 January 1990
David Ekserdjian, 'Introduction to the Thyssen-Bornemisza Collection',
 in *Old Master Paintings from Thyssen-Bornemisza Collection*,
 exhibition catalogue, Royal Academy, London, March 1988
Grace Glueck, 'What Big Business sees in Fine Art', *New York Times*,
 26 May 1985
Peggy Guggenheim, *Out of this Century: Confessions of an Art Addict*,
 André Deutsch, 1979
Francis Haskell, *Rediscoveries in Art: Some Aspects of Taste, Fashion
 and Collecting in England and France*, Phaidon, 1976
Andrew Horvat, 'The Patron Yen', *Antique Collector*, April 1990
Lana Joel, 'Art and Money: A New Type of Financing at Citibank',
 Journal of Art, Vol.I, No.6, June–July 1989
Karen Lipson, 'Works from Chase's "Hidden Museum"', *Newsday*,
 1986
Douglas C. McGill, 'New Chase Branch in Soho. An Art Gallery as Well
 as a Bank', *Living*, 17 April 1985
Robert Mahoney, 'Interview with Larry Gagosian', *Flash Art News*
Nancy Marx, 'Corporate Culture', *Manhattan, Inc.*, September 1986
James Roberts, 'Zen and the Art of Corporate Finance', *Artscribe
 International*, March–April 1989
Nancy Spector, 'The Dia Art Foundation', *Artscribe International*,
 January–February 1988
Calvin Tomkins, 'The Art World: Medici Inc.', *New Yorker*, 14 April
 1986
Calvin Tomkins, *Merchants and Masterpieces: The Story of the
 Metropolitan Museum of Art*, Henry Holt & Co., 1970
Hugh Trevor Roper, *The Plunder of the Arts in the Seventeenth
 Century*, Thames & Hudson, 1970
Hugh Trevor Roper, *Princes and Artists: Patronage at Four Hapsburg
 Courts 1517–1633*, Thames & Hudson, 1976

Chapter 4 Art of the State

Alan W. Barnett, 'Report from Haiti', *Art in America: The Global Issue*, July 1989

Thomas W. Braden, 'I'm glad the CIA is immoral', *Saturday Evening Post*, 20 May 1967

Eva Crockroft, 'Abstract Expressionism: Weapon of the Cold War', *Artforum*, June 1974

Philip Dodd, 'Art, History and Englishness', *Modern Painters*, Vol. 1, No. 4, Winter 1988–9

Deke Dusinberre, 'The Grand Louvre', *Art Monthly*, July–August 1989

Francis Frascina, 'L'Art en Europe at St-Etienne', *Art Monthly*, May 1988

Tony Fry and Anne Marie Willis, 'Aboriginal Art: Symptom or Success?', *Art in America: The Global Issue*, July 1989

Margaret Garlake, 'An Under-Developed National Gallery', *Art Monthly*, December–January 1987–8

Margaret Garlake, 'The 1987 Baringa/Nedlaw: An Outsider's View', *Insight* 187, December 1987

Margaret Garlake, *Thakor Patel*, catalogue introduction, 1989

Mark Gevisser, 'Review of *Art of the South African Townships* by Gavin Younge', *Art in America: The Global Issue*, July 1989

Serge Guilbaut, *How New York Stole the Idea of Modern Art: Abstract Expressionism, Freedom and the Cold War*, University of Chicago Press, 1983

Eleanor Hartney, 'The Whole Earth Show, Part II', *Art in America: The Global Issue*, July 1989

Janet Koplos, 'Through the Looking Glass', *Art in America: The Global Issue*, July 1989

Max Kozloff, 'American Painting During the Cold War', *Artforum*, May 1973

Michael Levey, *Painting at Court*, Weidenfeld & Nicolson, 1971

Thomas McEvilley, 'Ouverture de Piege: L'exposition postmodern et "Magiciens de la Terre"', *Magiciens de la Terre*, exhibition catalogue, Editions du Centre Pompidou, May 1988

Frances K. Pohl, 'An American in Venice: Ben Ahahn and United States Foreign Policy at the 1954 Venice Biennale', *Art History*, Vol.14, No.1, March 1981

Edward Said, *Orientalism*, Routledge & Kegan Paul, 1978

Abigail Solomon-Godeau, 'Going Native', *Art in America: The Global Issue*, July 1989

Chapter 5 The Shrine

Frances Borzello, *Civilising Caliban: The Misuse of Art 1875–1980*,
 Routledge & Kegan Paul, 1987
F. W. J. Hemmings, *Culture and Society in France 1789–1848*,
 Leicester University Press, 1987
Donald Horne, *The Great Museum: The Representation of History*,
 Pluto Press, 1984
Kenneth Hudson, *Museums of Influence*, Cambridge University Press,
 1987
Kenneth Hudson, *A Social History of Museums: What Visitors Thought*
 Macmillan 1975
Hilton Kramer, *The Revenge of the Philistines, Art and Culture
 1972–84*, Secker & Warburg, 1985
Jacques Maquet, *The Aesthetic Experience*, Yale University Press, 1986
'Mass MOCA: Showcase in Arcadia', *Art in America*, July 1988
'The Met Grill', *Metropolitan Home*, April 1988
Josep Montaner and Jordi Oliveras, *The Museums of the Last
 Generation*, Academy Editions, St Martin's Press, 1986
'The Musée d'Orsay: A Symposium', *Art in America*, January 1988
Michael Phillipson, *In Modernity's Wake, The Ameurunculus Letters*,
 Routledge & Kegan Paul, 1989
Francis Henry Taylor, *A Taste of Angels: A History of Art Collecting
 from Rameses to Napoleon*, Little Brown & Co., 1948

Sources of Quotations

Introduction

page 10 Frank Auerbach, quoted in *Past and Present: Contemporary Artists drawing from the Masters*, exhibition catalogue, Arts Council, 1987

page 13 Raymond Williams, *Culture*, Fontana, 1986

page 17 Tim Hilton, 'The Friends of Jimmy Whistler', *The Guardian*, 6 June 1990

page 18 Leon Golub, quoted in Anthony Sampson, *The Midas Touch*, BBC Books and Hodder & Stoughton, 1990

page 21 L. Baxandall and S. Morawski, *Karl Marx and Frederick Engels on Literature and Art: A Selection of Writings*, International General, 1974

Chapter 1 The Agony and the Ecstasy

page 27 Margaret Atwood, *Cat's Eye*, Bloomsbury, 1989

page 28 Andy Warhol, quoted in K. L. McShine (ed), *Andy Warhol: A Retrospective*, Museum of Modern Art, New York, 1989

page 31 Thomas Alva Edison, quoted in F. L. Dyer et al., *Edison: His Life and Inventions*, Harper & Row, 1910

page 32 P. P. Howe (ed), *The Complete Works of William Hazlitt*, 21 vols, 1930–4

page 40 Quoted in Octave Uzanne, *The Modern Parisienne*, Heinemann, 1912

page 43 Letter from Keats to G. and T. Keats, 13 January 1918. M. B. Forman (ed), *The Letters of John Keats*, Oxford University Press, 1947

page 45 Kurt Vonnegut, *Bluebeard*, Jonathan Cape, 1988

page 47 Don McLean, 'Vincent', from his album *American Pie*, United Artists Record

page 48 Steven Naifeh and Gregory White Smith, *Jackson Pollock:*
 an American Saga, Barrie & Jenkins, 1990
page 52 Linda Nochlin, 'Why Have There Been No Great Women
 Artists?', in T. B. Hess and E. C. Baker (eds), *Art and*
 Sexual Politics. Collier-Macmillan, 1973

Chapter 2 The Colour of Money

page 54 Stephen Sondheim and J. Lapine, *Sunday in the Park with*
 George, Nick Hern Books/National Theatre Publications,
 1990
page 57 Letter in *St. James's Chronicle*, 25 April 1761
page 63 Thomas Hoving (Director of the Metropolitan Museum of
 Art, 1967–77), on *The Midas Touch*, BBC 2, 1990
page 65 Martin Amis, *Money*, Jonathan Cape, 1984
page 66 Allan McCollum, quoted in *Allan McCollum*, exhibition
 catalogue, Serpentine Gallery, London, March 1990
page 68 Kevin Sullivan, 'The Japanese lead the world in prices, if
 not in taste', *The Guardian*, 17 May 1990
page 74 Anthony Sampson , on *The Midas Touch*, BBC 2, 1990

Chapter 3 The Power and the Glory

page 79 Alison Lurie, *The Truth about Lorin Jones*, Michael Joseph,
 1988
page 80 Mr Yasuo Goto (Chairman, Yasuda Fire and Marine
 Insurance Co.), on *The Midas Touch*, BBC 2, 1990
page 82 Henry James, *The American Scene*, 1907 (ed. Leon Edel,
 Hart-Davis, 1968)
page 84 Asher Edelman (contemporary art collector), on *The Midas*
 Touch, BBC 2, 1990
page 86 Baron Thyssen-Bornemisza, quoted in Brian James, 'The
 Passion and the Paintings', *The Times*, 7 March 1988
page 87 Bruce Chatwin, *Utz*, Jonathan Cape, 1988
page 89 Nelson Rockefeller, quoted in *Hans Haacke*, exhibition
 catalogue, Kunstverein, Frankfurt, 1976
page 91 Winton M. Blount (Chairman of Blount Inc.), 1984, quoted
 in Calvin Tomkins, 'The Art World: Medici Inc.' in *New*
 Yorker, 14 April 1986
page 94 Inscription on tabernacle in the Church of SS Annunziata,
 Florence, commissioned from Michelozzo by Piero
 de'Medici, quoted in Anthony Sampson, *The Midas Touch*,
 BBC Books and Hodder & Stoughton, 1989

page 95 Isaac Pereire, art collector, in Edmond and Jules de
 Goncourt, *Journal-mémoires de la vie littéraire*, Paris,
 1887–96. Quoted in Haskell, *Rediscoveries in Art*, op. cit.

Chapter 4 Art of the State

page 107 Robert Motherwell, 1946, quoted in Serge Guilbaut, *How
 New York Stole the Idea of Modern Art*, University of
 Chicago Press, 1985
page 110 Letter to *The Times*, 19 November 1946
page 111 Antoni Tàpies, Catalan artist, quoted in *Catalonia Culture*,
 exhibition catalogue, Centre Unesco de Catalunya,
 Barcelona, January 1987
page 113 John Peale Bishop, 1941, quoted in Serge Guilbaut, op. cit.
page 114 Peter Fuller, *Modern Painters*, Spring 1988
page 121 Deanna Petherbridge, *Temples and Tenements: The Indian
 Drawings of Deanna Petherbridge*, Seagull Books in
 association with Fischer Fine Art Ltd, Calcutta, London,
 1987
page 122 Letter of Camille Pissarro, quoted in *Art in America: The
 Global Issue*, July 1989
page 124 David Alfaro Siqueiros, *Art and Revolution*, 1975, quoted in
 Art in Latin America, exhibition catalolgue, Hayward
 Gallery, London, 1989
page 128 Frantz Fanon, 'On National Culture', in *The Wretched of the
 Earth*, MacGibbon & Kee, 1965
page 130 Anish Kapoor, 'Pigments of the Imagination', *Sunday
 Correspondent*, 13 June 1990

Chapter 5 The Shrine

page 134 Theodor Adorno, quoted by Douglas Crimp, 'On the
 Museum's Ruins', in Hal Foster (ed), *PostModern Culture*,
 Pluto Press, 1985
page 136 Francis Henry Taylor (Director, Metropolitan Museum of
 Art, 1939–55), quoted in Calvin Tomkins, *Merchants and
 Masterpieces. The Story of the Metropolitan Museum of Art*,
 Longman, 1970
page 138 Museum of Modern Art, New York, statement on its
 reopening on 7 May 1984, quoted in Hilton Kramer, *The
 Revenge of the Philistines: Art and Culture, 1972–84*,
 Secker & Warburg, 1986

page 139 Kenneth Hudson, *Museums of Influence*, Cambridge
 University Press, 1987
page 140 W. Wackenrode, *Herzengiessungen eines Kunstliebenden
 Klostenbruders*, 1797 (ed. J. L. Tieck, Leipzig, 1938)
page 142 *Batman: The Art of Crime*, D.C. Comics Inc., 1989
page 145 *First Futurist Manifesto*, in *Le Figaro*, 2 February 1909
page 153 Andy Warhol, quoted in K. L. McShine (ed), *Andy Warhol:
 A Retrospective*, exhibition catalogue, Museum of Modern
 Art, New York, 1989
page 157 Thomas Krens (Director of Mass MOCA and of the
 Guggenheim Museum), quoted in 'Showcase in Arcadia', *Art
 in America*, July 1988
page 161 Gérard Régnier (Director, Picasso Museum, Paris), 'How
 Vital Are Museums?', *Art International*, Spring 1990

Index